GHOSTS
OF THE
RIO GRANDE VALLEY

GHOSTS
OF THE
RIO GRANDE VALLEY

DAVID BOWLES
ILLUSTRATIONS BY JOSÉ MELÉNDEZ

Published by Haunted America
A Division of The History Press
Charleston, SC
www.historypress.net

Copyright © 2016 by David Bowles
All rights reserved

Illustrations by José Meléndez

First published 2016

Manufactured in the United States

ISBN 978.1.46711.992.4

Library of Congress Control Number: 2016938313

Notice: The information in this book is true and complete to the best of our knowledge. It is offered without guarantee on the part of the author or The History Press. The author and The History Press disclaim all liability in connection with the use of this book.

All rights reserved. No part of this book may be reproduced or transmitted in any form whatsoever without prior written permission from the publisher except in the case of brief quotations embodied in critical articles and reviews.

CONTENTS

Introduction 7

CAMERON COUNTY
1. Port Isabel Lighthouse 11
2. The Phantoms of Fort Brown 19
3. The Haunting of the Colonial Hotel 30
4. The Wailing Woman of San Benito 37
5. The Harlingen Insane Asylum 49

WILLACY COUNTY
6. San Perlita and the Devil's Lagoon 59
7. The Lonely Ghost of Lyford 68
8. Willacy County Courthouse 74

HIDALGO COUNTY
9. The Revenants of Llano Grande 83
10. Old Hidalgo County Jail 88
11. The Wraiths of the San Juan Hotel 95
12. McAllen's Casa de Palmas Hotel 104
13. La Lomita Chapel 111
14. Shary Mansion 118

Contents

Starr County
15. Fort Ringgold	129
16. LaBorde House	138
17. The Woman in White at Roma	147
Bibliography	155
About the Author	157

Introduction

My family has deep roots in the Rio Grande Valley, a unique area in deep South Texas that abuts the Rio Grande. Carved from Spanish land grants in the late nineteenth and early twentieth centuries by entrepreneurs and opportunists, the four-county stretch of territory boasts a unique social milieu, a *mestizaje*—or spicy mélange, if you will—of very different cultures forged together in the crucible of history.

Cameron. Willacy. Hidalgo. Starr. Each of these counties features multiple communities—whether cities or unincorporated areas—with both their individual natures and the shared identity of which so many in this region have grown increasingly proud.

I have lived in the Valley—as we call this floodplain, dotted with oxbow lakes, thick with brush—nearly my entire life, regaled since childhood with tales of witches, demons and monsters by my grandmother Garza, my parents and my various aunts and uncles, none of whom could resist scaring a little boy with tales of *cucuys*, boogeymen that roam the dark.

Ghosts stories were different. I didn't find them quite as terrifying—the phantoms had been people once, after all, and I was drawn to understanding why they had lingered. What set of circumstances had resulted in their deaths? What was it about those deaths that had tethered the souls of those who should have departed to the site of their demise?

Adults didn't have answers for me. They never did, it seemed. But I could see the patterns, and I could ask the right questions.

Introduction

To understand the sightings of our local ghosts, I needed to learn our history. As I grew older and more skeptical, I stopped seeing phantoms as actual, objective phenomena. But I believed in them nonetheless, saw them as the scars upon our folklore left by the traumas of the past.

So I delved deeper, discovered the untold stories of the Valley's bloody birth. Every haunting struck me as a clue, an indictment of some cosmic wrong I still struggle to tease out.

This collection, then, can be read two ways. I give you the historic context and the spectral legend. It is entirely up to you whether to take the apparitions as real or imagined.

Either way, the ghosts haunt us.

CAMERON COUNTY

1
PORT ISABEL LIGHTHOUSE

THE HISTORY

A picturesque town sits at the easternmost edge of Cameron County, where Texas State Highways 48 and 100 converge near the Laguna Madre, an extensive though shallow hypersaline lagoon that stretches between the Texas coast and Padre Island. Often treated as a mere gateway to the more tourist-frequented South Padre Island, this community—Port Isabel—is a treasure horde of history and legend.

There are many haunted locations in the city of Port Isabel, residents affirm. The Historic Queen Isabel Inn, opened by railroad magnate Caesar Kleberg in 1906 as the Point Isabel Tarpon and Fishing Club, served as the only local hotel for two decades, becoming the focal point for some of the area's most important events, like President Warren G. Harding's last vacation before his swearing in and the yearly Rio Grande Valley Fishing Rodeo. Though several hurricanes did their best to put the hotel out of commission, it remained standing, and those who visit its stately rooms report hearing the footsteps of the dead echoing down its halls.

Those same storms sent many ships to their doom before the construction of the lighthouse. If you look out across the bay under the right sort of moonlight, the old folks will tell you, you might just see ghost ships plying the gentle waves before being lost in the early morning mist.

In 1926, the Yacht Club Hotel was built to serve the needs of the Rio Grande Valley's elite, men like land baron John Shary. The ritzy spot hosted

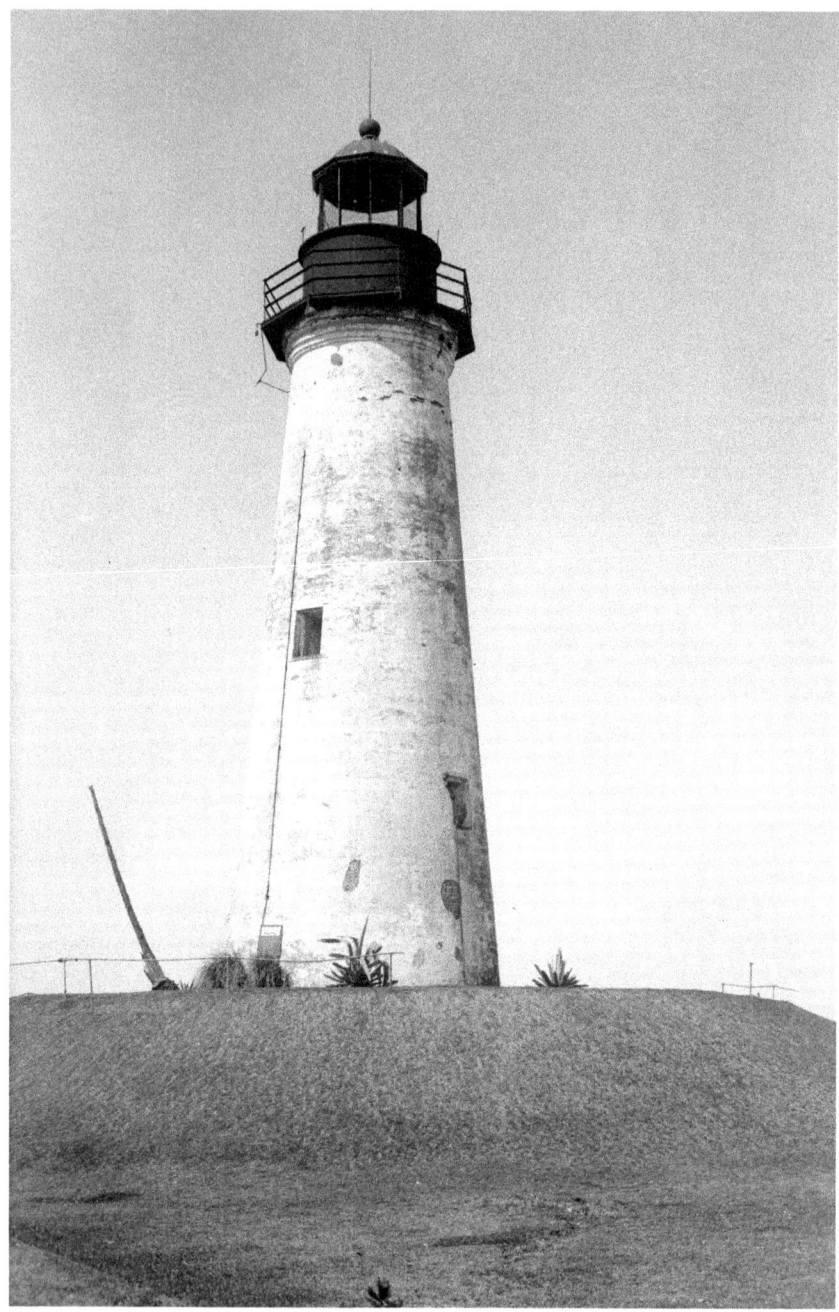

The Port Isabel Lighthouse before full restoration. *Library of Congress.*

visitors as legendary as Amelia Earhart and Al Capone; it also witnessed great tragedy, such as when a yacht burned to cinders nearby, killing a well-to-do couple visiting from New England. But like many spots along the U.S.-Mexican border, the hotel absorbed some glimmer of their souls. For to this day, visitors swear they see a young man and woman decked out in the gaudy clothes of the 1920s, chatting and laughing before fading just as one approaches to meet them.

Indeed, Port Isabel has a long and variegated history. Brazos Island, just south of South Padre Island, was first settled in the eighteenth century as a series of wharves along the bay—facilitating the transportation of goods upriver past the sandbars at the mouth of the Rio Grande. The inhabitants, striking out for fresh water, found themselves in the area of present-day Port Isabel. In fact, legend has it that pirate Jean Lafitte established a fifteen-foot well just northwest of there in the early 1800s to better provide for his privateering ventures.

By the 1830s, a small community had sprung up around these water sources. It called itself El Frontón de Santa Isabel, but that name would change multiple times over the next quarter century: Punta de Santa Isabel for most of the Mexican-American War, Point Isabel with the establishment of a post office, Brazos Santiago when the Oblates of Mary Immaculate established the chapel of Our Lady by the Sea and finally—after a horrible cholera epidemic—to Port Isabel.

With the Mexican War over, Fort Polk—which had stood at the heart of Port Isabel, providing medical care and provisions to the army—was abandoned in favor of a stronger garrison at Fort Brown to the south. By 1853, upon a mound where the fort had stood, the Port Isabel Lighthouse had been erected at last as a beacon to guide ships safely to harbor. Commerce boomed as a result, with $10 million worth of cotton passing annually through the port, even during the early years of the Civil War, when the area became a refuge for blockade runners. Such Confederate efforts shifted south to the Mexican town of Bagdad after Union forces seized or destroyed every last ship in the harbor in May 1863.

During the remainder of the war, the lighthouse was occupied intermittently by soldiers from both sides to serve as a lookout, and fresh battles were waged around its broad base. Even a month after General Robert E. Lee's surrender at Appomattox, Union and Confederate troops strove with one another at Palmito Ranch, not far from the lighthouse, in the very last battle of the war. Hundreds of men had died during the long years of the conflict, joining the many others who had succumbed less than

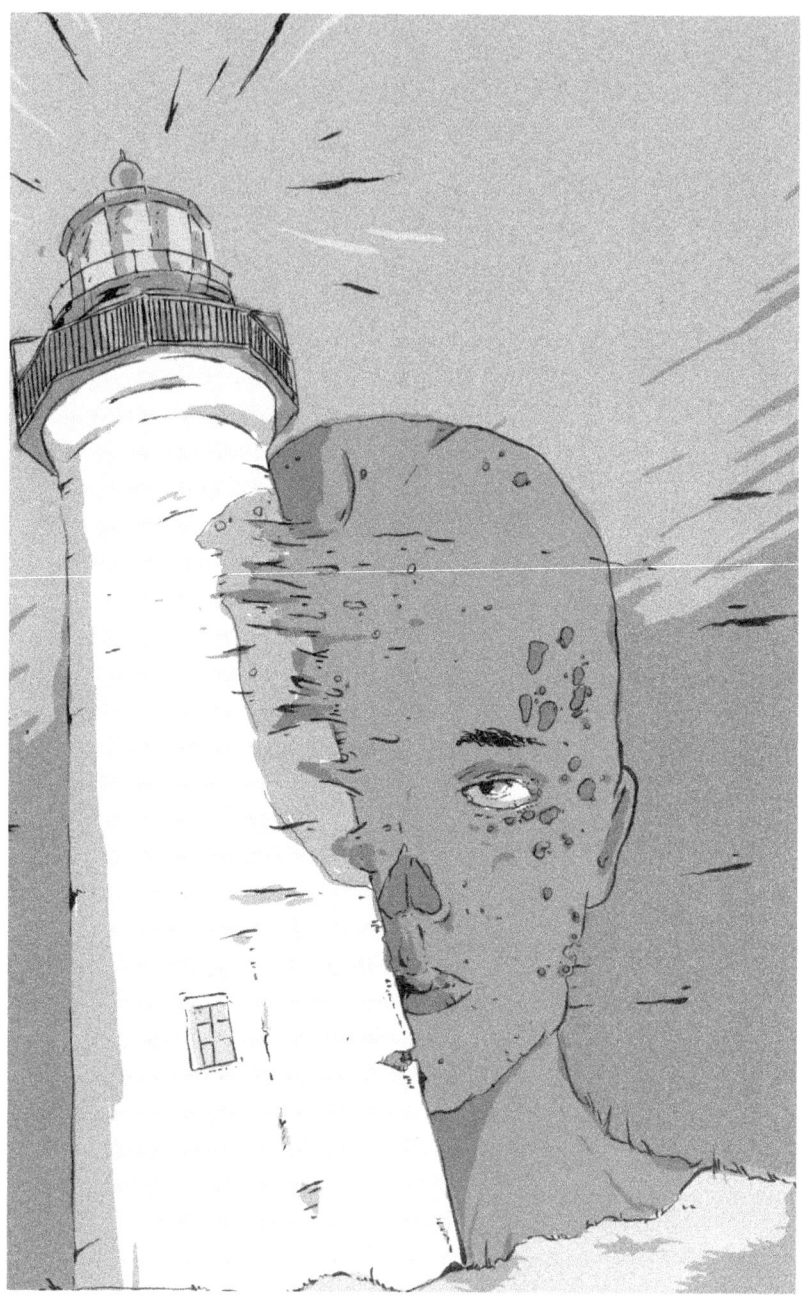

The angel of the Port Isabel Lighthouse. *José Meléndez.*

two decades earlier during the Mexican-American War. Locals whispered rumors of bodies lying in unmarked graves nearby. By the time the Rio Grande Valley Railway had connected Port Isabel to Brownsville, people were ready to turn away from the technology of the past and the deaths associated with fort, lagoon and sea.

Despite some structural improvements in the waning years of the nineteenth century, the town let the gleam of the lighthouse flicker out forever in 1905. Its crown darkened, its stone walls growing moldy with age, the tower waited unused for forty-five somber years. Then the one-acre plot on which it stands was donated to the state in 1950 as a historic site by Mr. and Mrs. Lon C. Hill Jr. and the Port Isabel Realty Company. After two years of extensive renovation, the lighthouse opened to the public. Tourists and locals alike delight in the giant of white stone, working their way up the seventy-five steps of the winding stair to peer out over the bay from the highest vantage point in the area.

THE LORE

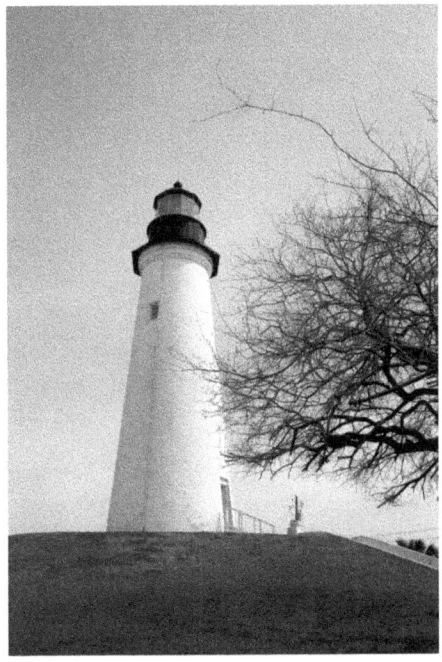

The Port Isabel Lighthouse today. *Alexis Tran.*

For the better part of a century, locals and visitors have claimed to see the ghosts of soldiers or victims of cholera wandering around the area at dusk. Some speculate that the inadequacy of their burials in times of conflict and despair may have kept these souls from their eternal rest.

Perhaps more fascinating are the multiple sightings of an incorporeal being known as the Lighthouse Angel. The stories of this ethereal guide go back to the nineteenth century, when ships would occasionally approach the harbor in the midst of powerful storms. The swirling winds, experts say, created vortices on either side of the tower,

which were lit up by its powerful lamp. The light was also refracted by rain above the cupola to create the illusion of a halo. The overall effect, sailors insisted, was that a massive angel stood on shore, casting a miraculous glow into the tempests.

Despite the surety of modern science about the source of this optical effect, there is reason to believe that the Lighthouse Angel is more than just the interplay of light and rain and wind. To this day, stories persist about the warnings the angel sometimes whispers to tourists as they ascend the spiraling stair, cautionary words that have even saved lives.

Among those attracted to the Port Isabel Lighthouse are couples wanting to exchange vows at the top. Many insist on tying the knot this way despite the growing body of testimony about disembodied souls that cling to the site.

The Legend

Elena González and Oscar Dresch were not ignorant of these tales when they arranged for a short civil ceremony beneath the glittering glass dome at the lighthouse's summit. But getting married there and spending a honeymoon in Mexico City were part of Elena's dream, so Oscar set aside his superstitious bent to please his fiancée.

Elena's parents had come to the United States as part of the old Bracero Program, and by dint of their hard work and united spirit, they had constructed a happy, healthy life for their children. Elena had never had the chance to return to their motherland; when she had met Oscar at Pan American College and the two had fallen in love, she had shared her dream of visiting every major city in Mexico. A political science major fascinated with that country himself, Oscar had enthusiastically seconded that plan not long after proposing to her.

As agreed upon in advance, the justice of the peace was waiting for them on the grassy knoll when they drove up, an employee from the visitor center beside him to serve as a witness. Elena waited for Oscar to open the door for her, and then she stepped out of the car into the lovely September morning sunlight, almost ethereal in her beauty, draped in a simple white sundress. For Oscar, she had picked a matching guayabera and chinos. She wanted to remember the moment as pure and transformative, a decisively beautiful time in her life.

"Great choice," the judge said in greeting, gesturing at the lighthouse. "Up nearer to heaven. The weather's perfect, too. María here will snap a couple of Polaroids. Feel free to take one."

Oscar nodded, turning to Elena as the four of them headed toward the entrance. "Are you ready, love?"

"More than ready. Ecstatic."

They began to climb to the top, Oscar bringing up the rear. He was in a sort of reverie, stunned by his magnificent luck at convincing such a beautiful woman to marry him. Even the lighthouse, which had filled his dreams with formless specters for several weeks, was altered utterly, made paradisiacal before his enamored eyes.

But then, halfway up, he felt a wave of unexpected cold pass through him, like the chill northern wind on a late January evening, snatching at meager Valley coats. As he stopped and shivered, a voice whispered in his ear.

"Don't go. Don't go."

Swiveling his head around, Oscar sought out the source of the plea. No one was there beyond the other three, whom he had already lost sight of.

Tentatively, he asked aloud, "Don't go where?"

"Mexico City," came the reply, fading as if the speaker were receding in the distance. "Danger there. Don't go."

There was nothing more.

After a moment, Elena called his name from above, and Oscar shook off his confused paralysis. Smiling, he joined the others at the railing, the sun glinting off glass and metal to transform the small space into an almost celestial chamber.

It was not until later, after rings and vows had been exchanged and the couple found themselves driving back to their hotel, that Oscar mentioned the incident to his new bride.

"Are you sure?" she asked, her expression souring. "I mean, you are a little susceptible to suggestion and superstition, Oscar."

"Yes, I'm sure. I really think we should cancel the flight. Or change it. What about Acapulco? You've always wanted to go there, too. We can spend a few days out on the beach. Doesn't that sound fun?"

Elena was not happy about having her careful plans ruined. But she saw how upset Oscar was by the supposed warning, and she did not want their marriage to get off to a rocky start.

The following day—September 18, 1985—their plane touched down in Acapulco, and they had a lovely evening at the water's edge, dining as they

watched the sun plunge into the Pacific, then walking hand in hand along the beach, the stars breathtakingly brilliant above them.

It was the perfect end to their first full day as man and wife.

Oscar started awake the next morning. It was 7:00 a.m.

"Did you feel that?" he asked Elena. "Like the bed just moved."

He got dressed and went down to reception. Everyone was gathered around a television in the lobby, silent as the newscasters spoke in somber tones. There had been a horrible earthquake, one of the strongest on record. The tremors were felt as far away as Houston and Los Angeles.

Mexico City was in ruins. More than five thousand people perished.

Once more, the Lighthouse Angel had saved those she could from the perils of the world.

2
THE PHANTOMS OF FORT BROWN

THE HISTORY

About thirty minutes southwest of Port Isabel, at the juncture of Highways 48 and 281, the city of Brownsville sprawls at the very tip of Texas.

Though explorers had swept through the area in the seventeenth century, no real attempt was made to settle until late in the eighteenth. San Juan de los Esteros, which would become the modern city of Matamoros, was founded in 1765 on the south bank. Sixteen years later, the Spanish crown granted fifty-nine leagues of land to José Salvador de la Garza, a vast swatch of land north of the river that included the site of the future town of Brownsville. De la Garza established a ranch there, and gradually a handful of herders and farmers were drawn to his property.

Rising tensions between the newly independent Mexico and the even newer state of Texas prompted the U.S. government to build a fort on the lower end of the Rio Grande Valley. Before it could be completed, however, Fort Texas found itself under siege in the first active campaign of the Mexican-American War in May 1846. General Zachary Taylor led his forces to their aid, but he was intercepted by Mexican troops, and their military engagement, the Battle of Palo Alto, officially launched the war just five miles from what would become the heart of Brownsville. After another battle, Taylor reached Fort Texas and discovered that its commander, Major Jacob Brown, had been killed during the siege. The fort was renamed in his honor.

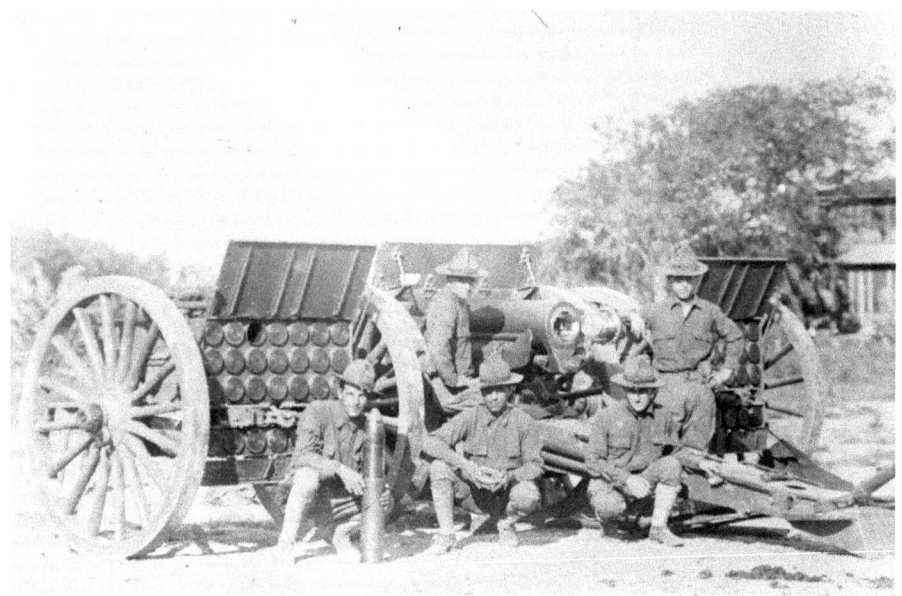

Soldiers at Fort Brown. *Library of Congress.*

When the war came to an end at the signing of the Treaty of Guadalupe Hidalgo, a city bearing the major's name was founded by Charles Stillman, who had bought a sizeable piece of de la Garza's grant from the first wife of José Narciso Cavazos, heir to the ranch's holdings. The problem was that Cavazos had remarried, and the children of his second wife, principally Juan Nepomuceno "Cheno" Cortina, were the actual holders of the property's deed. The legal struggle between Cortina and the Anglo founders of Brownsville would stretch on for years and result in considerable bloodshed before the U.S. Supreme Court finally ruled in favor of Stillman in 1879.

Despite the disputes, Brownsville became the county seat of the Cameron County on January 13, 1849, with official incorporation from the state coming a year later.

It did not take long for the population to swell to more than one thousand souls, many of them immigrants crossing from Matamoros or would-be miners stopping over before heading to find gold farther west. A cholera epidemic struck in the spring of 1959, killing close to five hundred men, women and children. Yet the boom continued, and Brownsville gradually displaced Matamoros as the center of trade in the region.

On July 13, 1859, after ten years of tension between Cheno Cortina and the Anglo ruling class, the situation in Brownsville took a startling turn for the worse. Cortina, a businessman who had transformed himself into a champion of the rights of Mexican Americans in the Rio Grande Valley, took over Brownsville with a contingent of rebels after abuses by local law enforcement. The town was temporarily evacuated, and several armed conflicts ensued. Eventually, Cortina found himself retreating up the river, pursued by Texas Rangers under the command of Colonel John Salmon "Rip" Ford. At Rio Grande City, he and his supporters were pushed into Mexico.

Arguably, Brownsville's involvement in injustice continued long past these engagements. During the Civil War, the town help bust Union blockades, transporting Confederate goods into Mexico, especially cotton grown and harvested with slave labor, which was then smuggled to European ships waiting at the Mexican port of Bagdad. In this nefarious work, the town was aided by Fort Brown, under Confederate command, until Union troops landed at Port Isabel and marched for Brownsville in November 1863 to put a halt to the illicit trading. During the Battle of Brownsville that followed, Confederate forces withdrew from the fort, blowing it up as they fled. But they were back in 1864, occupying Brownsville under the leadership of Rip Ford.

Confederate hold on the lower Rio Grande Valley was tenacious. On May 15, 1865, a full month after the South had surrendered at Appomattox, the Battle of Palmito Ranch was fought and won by soldiers in gray.

In the aftermath of the war, Fort Brown was rebuilt and strengthened. A post hospital was completed in 1871, and a decade later, it found itself in the midst of a regional outbreak of yellow fever.

To this struggling hospital arrived William Crawford Gorgas, a twenty-seven-year-old doctor whose experiences in the Valley would prompt him to combat the disease for three decades until he finally found a cure. When he showed up at Fort Brown in 1882, the epidemic was devastating the local population, overpowering its victims with body aches, fever and nausea that caused them to vomit black bile. In order to keep up with the mind-boggling mortality rate, fresh graves—dug daily by the doctors themselves—waited gaping and hungry for another victim.

The panic nationally was palpable. The disease had elsewhere wiped out entire armies and thousands of civilians in other similarly tropical climates. Gorgas, intent on finding a solution to the burgeoning problem, began dissecting bodies in the morgue, known informally as the "dead house." Because of the commander's fears of losing a valuable physician, Gorgas was

The Fort Brown guardhouse. *University of North Texas Libraries.*

ordered to stay away from patients. He refused and was briefly arrested before he managed to convince his superiors of the need for research.

Gorgas became symptomatic, suffering for weeks through the debilitating ravages of yellow fever. But he emerged from the illness at the end, now permanently immune and more eager than ever to work with patients. One day, he was approached by another doctor as they both stood above an open grave at the Brownsville National Cemetery on a nearby island. The doctor requested Gorgas read a burial service for Marie Cook Doughty, a nurse whose drawn-out, fifteen-day illness suggested she was about to die.

Gorgas agreed, but he set out to treat her, hoping that the path out of the jaws of death he had trod could be taken by Doughty as well. He visited her in the cool dark of night, talking to her softly. Though she could barely make out his features, the musical tones of his voice comforted her, and in her delirium she called him the "Gorgeous Doctor" instead of Dr. Gorgas.

Marie recovered at last and became wholly dedicated to the man who had saved her. Their partnership lasted a lifetime, and she was at his side during every campaign in his lengthy battle to eradicate yellow fever.

The Gorgas building at the former Fort Brown. *Alexis Tran.*

Fort Brown served the Valley for many decades more until it was at last decommissioned in 1945. The Junior College of the Lower Rio Grande Valley—which would later become Texas Southmost College, the University of Texas at Brownsville and finally the University of Texas Rio Grande Valley—purchased the land and the buildings that remained.

Inadvertently, the college also inherited a plethora of phantoms.

THE LORE

Brownsville's storied history includes many haunted nooks and crannies.

Camp Lula Sams was founded in 1953, and thousands of Girl Scouts visited over the decades until the camp was sold in 1997, passing through various hands until acquired by a charter school to use for outdoor classrooms. Strange rumors persist to this day, claiming that despite the previous owners' denials, the camp was shut down after a deranged counselor raped and killed some of the girls in attendance. Folks affirm that at night girls can be heard weeping piteously.

Farm Road 511 gets a respectable amount of traffic, but some of those driving down it in the wee hours of the night have seen a most peculiar sight—ghost cows. The bovine specters loom out of nowhere, causing drivers to swerve out of the away only to witness the disappearance of the phantom cattle. A few cars have flipped or slammed into oncoming traffic, reports say.

Another haunted stretch of blacktop is Stanolin Road. The legend claims that a man was driving too fast down the road years ago and ended up dying in a fiery crash. A cross was set up on the side of the road to memorialize the spot. Some people who have driven past the marker insist they saw a man smiling as he moved to approach their cars. Once they realized that he was a ghost, most drivers fled the scene as quickly as possible.

Local campuses have also reported hauntings. In Rivera High School, for example, a girl was reportedly murdered in a shower stall in the girls' locker room. Now her spirit lingers there and in the gym, giving quite a fright to students and coaches alike. Some witnesses report hearing a desperate scream and the sound of a body slammed against the lockers. Girls changing after physical education class have said that the showers will suddenly shut off as some sort of ectoplasm swirls away down the drain. The school also houses ghosts who flush toilets unexpectedly or bounce phantom basketballs in the silent, empty gym.

The most notable of the hauntings happen at the university, in the area formerly occupied by Fort Brown and its soldiers. Revenants of cavalrymen and women in Victorian apparel have been seen wandering the old buildings. Books have flown off shelves in the library, and music was apt to begin playing from jukeboxes though no one had selected a song. Students and staff are certain these are the acts of the restless dead since the library was once parade grounds where military deserters were hanged and the dormitory was atop disturbed burial sites. Given the thousands dead from both cholera and yellow fever, not to mention from the many battles fought nearby, no one is particularly surprised that ghosts throng on the grounds.

What is shocking is that some of these phantoms have spoken.

The Legend

Fernando Leal was a middling farmer eking out a living in the late nineteenth century. After a dispute with his father, he moved to Matamoros. In less than a year, he had married a girl from Saltillo and set himself up as a tenant

farmer, giving a large portion of his crops to the hacienda and fuming at the injustice of the system. By early 1882, with a toddler son and young wife to care for, Leal had finally grown tired of backbreaking work with little reward. "There must be something else," he thought.

In late February, his cousin Ricardo visited the small farm and made an interesting offer.

"Come with me on a drive, Fernando. There's a cattle queen wants a few thousand head taken from Brownsville to Dodge City. They're looking for men."

"Ricardo, I'm a farmer. What do I know about steers and cows?"

"Don't worry about that. Lots of hands are greenhorns when they sign up. You learn as you go. And you might not know much about cattle, but you understand horses pretty well. That's what we'd be, Fernando. Wranglers. Pays $50 a month."

Fernando's eyes widened at the sum.

Ricardo, hopeful, pushed a little more. "Besides, you grew up around Anglos in Texas. You've got more English than me. I could use your help with the cowboys."

Trying to hide his excitement at the prospect, Fernando said he would sleep on it. That evening, though, as he told his wife, Raquel, about the job, he could not suppress his enthusiasm.

"I'll make more in five months than we could in three years selling crops, Raquel!"

"I don't know, Fernando," she said as she fed their son a thin bean soup. "The idea of you being away from us that long worries me. I don't have any relatives here, and most of your family lives in Brownsville."

"Ah, that's not a problem, my love. The neighboring tenant farms are full of good people. They'll help if you need something."

In the end, the benefits outweighed the cost. Fernando and Ricardo signed up for the drive, and by early April they were driving a dusty herd of Longhorns up the Chisholm Trail, wending their way between newly erected fences and other more natural barriers.

The work was hard but rewarding, and Fernando soon found he had a knack for it. For the first time in years, he felt competent and satisfied. The bad habits of other wranglers, waddies and cowboys rubbed off on him, though—he acquired a taste for tobacco and liquor that slowly began to erode his savings.

By August, the team had reached the stockyards of Dodge City, Kansas, a town unlike any Fernando had ever seen. His fellow hands dragged him immediately to the China Doll Brothel.

For a moment, Fernando balked at the suggestion that he hire a girl. He loved his wife, he argued. He could not be unfaithful to her.

But the cowboys ridiculed him relentlessly, and the women were so very lovely.

Raquel managed as best she could while her husband was away. With the generosity of others, she and little Rubén made it through the spring and most of the summer.

But as August waned, yellow fever spread like a miasma across northern Mexico and South Texas. Raquel heard the tragic stories as more and more people fell ill, many dying. It was like a distant horror, though, until Rubén began to run a fever. The little boy became listless, keening in pain, refusing to eat, vomiting whatever food his mother managed to force him to swallow.

After four days, his skin became jaundiced, and his vomit streamed black onto the dirt floor.

Raquel rushed her son to a neighbor's home, begging for advice.

"Take him to Fort Brown," the woman advised. "They have good doctors there who can treat the plague."

As she made her away across the silty Rio Grande, however, Raquel felt the fever begin to burn madly in her flesh as well.

News of the epidemic reached Kansas. Fernando read the broadsheets with sinking dread. A sanitary cordon had been put in place by the federal government, though the leaders of Brownsville were fighting the decision, decrying it as illegal.

"Even if I could return," Fernando reasoned, "I might get sick on the way. Then I would be a double burden."

For the wrangler, after two solid weeks of debauchery, had only a few silver dollars left to his name.

"What do I do?" he demanded of Ricardo.

"Well, your wife and son have waited this long. And the quarantine would probably keep you from them anyway. I'm hearing that the U.S. government is happy to let Mexican Americans die inside that cordon. So stick around. Try your luck at cards or something. Make your money back so you don't disappoint Raquel."

So Fernando Leal became a frequent customer at the Long Branch Saloon, falling in with hardened gamblers in a last-ditch attempt to wring some success out of the cattle drive. At first, luck was on his side—he leveraged his few dollars into a few hundred. But the thrill of winning became addictive, and he took stupid risks. When he was down to just twenty-five dollars, he realized that he was out of his depth and three months overdue back home.

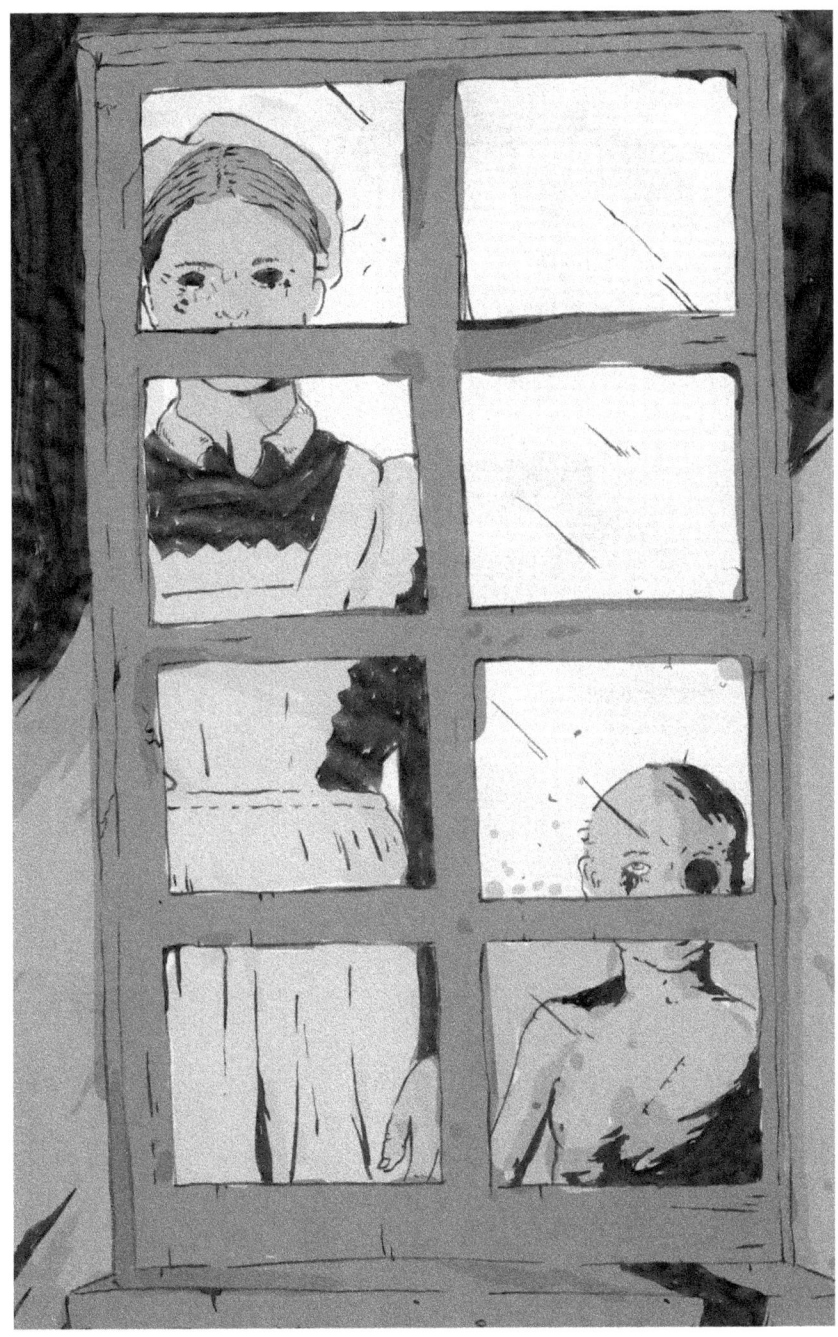
Ghosts at the former Fort Brown. *José Meléndez.*

It was a frugal, hard trip back to Matamoros. Fernando had a lot of time alone to reflect on the flaws in his character. He resolved to apply himself wholly to farming and family, the life God had ordained for him.

When at last he dismounted at his home, he found it dusty and disused. There was no sign of Raquel or Rubén, and the field was choked with weeds. Galloping to his neighbors' tenant farm, he learned of his son's illness and his wife's decision to seek help across the river.

Though he risked becoming trapped within the cordon until the quarantine was lifted, Fernando did not hesitate. He spurred his tired horse back to the United States.

It took some convincing to get past the soldiers. They confiscated Fernando's horse and impounded his rifle. None of that mattered. As soon as he was able, he made his way through the fort, past the barracks, toward the hospital.

Amazingly, he found Raquel waiting for him, standing in an archway, a faraway look in her hollow eyes. The wind snapped a ragged hospital gown in lashes against her sallow skin. She flinched away when he reached out to embrace her.

"I can't find him, Fernando. Help me find him. The doctors took him. Where is he?"

Her voice began as a monotone but rose to a desperate shriek. As Fernando stepped closer to her, however, she faded with a final groan and rushed *through* him, driving a bitter cold into the very core of his being.

Shaken and overwhelmed, Fernando stumbled and spun, searching for his wife. She was gone.

Desperate for answers, he made his way inside the hospital. He opened door after door, poking his head in to scan each room, until a nurse approached him and addressed him in Spanish.

"Can I help you?"

"I'm looking for my wife. I just saw her . . . or thought I did. She and my son came here looking for help. He had the plague."

She nodded, compassion in her eyes. "I understand. What were their names?"

"Raquel. Rubén. Leal."

The nurse glanced away for a moment, breathed deeply. Then she stepped closer to him. "I'm afraid it couldn't have been your wife you saw, Mr. Leal. She . . . she passed away."

Fernando's world tilted horribly as she explained. Soon after arriving, Raquel had been separated from her son, who needed intensive intervention

from Dr. Combe and Dr. Mellon, the physicians charged with treating the worse cases. But Raquel was also symptomatic, so Dr. William Gorgas, himself just recovered from the fever, did what he could to ease her discomfort. Then had come the horrible news—Rubén had succumbed. The mother had deteriorated quickly after that, swearing that her son was still alive, that she had seen him wandering the fort grounds.

In the end, Gorgas had helped dig her grave, wrapping her corpse in a white shroud, adding quicklime to the coffin before easing her form inside. As she was lowered into the earth, the doctor had read a quick burial service by the light of a sputtering lantern. With so much death, there was no time for priests and solemn rites.

When he finally recovered from the shock, Fernando understood that his wife's spirit had appeared to him. She was not at rest. Nor, from her final ravings, was their son.

Spending the last of his gambling profits, Fernando brought a priest in to sanctify the soil and say the holy words over the bodies of his beloved wife and child. At least in death he would give them the peace he had failed to provide in life.

Yet peace seldom lasts forever. In 1909, the decision was made to move 3,800 bodies buried near Fort Brown to Alexandria, Louisiana. The graves of war heroes were dug up along with those of cholera and yellow fever victims. More than 1,500 of these remains were declared "unknown" and buried in a mass grave marked by a single granite monument.

The job was poorly done. Some remains were left behind near Brownsville in disturbed and profaned earth. When the summer of 1933 brought three violent hurricanes slamming into the Gulf Coast, flooding loosened the earth and sent rotted coffins spilling into the nearby oxbow lake.

To this day, restless souls roam the university buildings and other establishments erected upon such tragic foundations. Indeed, students claim to have spoken to a young boy wearing clothes from another time.

"Find my mother," he whimpers in Spanish before fading away. "She's here, somewhere. Tell her not to cry for me. I am fine. I am fine."

3
THE HAUNTING OF THE COLONIAL HOTEL

THE HISTORY

Before the arrival of Europeans to the Americas, the Lépai-Ndé, or Lipan Apache, hunted seasonally, ranging from the Colorado River to the Rio Grande. Their principal homeland was Central and South Texas, an area they called *Kónitsąąíí gokíyaa*—Big Water Country.

As their rivals, the Comanche, were displaced by the westward expansion of the United States, the multiple Lipan bands found themselves driven deep into that homeland, their movements restricted by conflicts with the government of New Spain as it pushed its frontier northward. Some sought the protection of Spanish missions, converting to Catholicism and adopting the new culture. Others clung to tradition as fiercely as they could, even as Anglos began to encroach and Mexico became an independent nation. A few of these groups remained in the Rio Grande Valley alongside the Coahuiltecan peoples native to the region, coalescing into communities the Spanish called *rancherías*.

In 1784, King Charles III of Spain awarded the San Pedro de Carricitos land grant to Pedro Villarreal. This sprawling property comprised some twelve thousand acres in what is today Cameron County. A Lipan village at its southernmost edge (just fourteen miles from modern Brownsville) was left largely autonomous—the descendants of the inhabitants of El Caláboz Ranchería still live and work in the area today, struggling against injustices, indignities and cultural erasure.

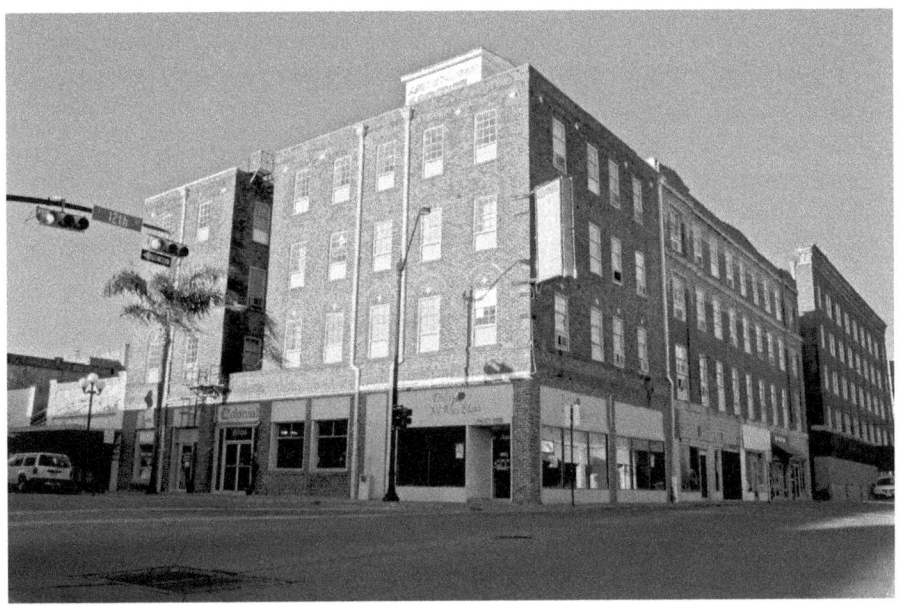

The Colonial Hotel. *Alexis Tran.*

Sometimes injustice entails desecration. Fittingly, in the tradition of many Apache bands, the soul of a desecrated enemy can linger on earth, felling his surviving foes with ghost sickness.

THE LEGEND

On Levee Street in downtown Brownsville stands an impressive brick edifice with an interesting reputation—the Colonial Hotel, still popular despite being very haunted.

Many tales have been told down the years of unexplained activity in the hotel. Room 101 has become a focal point for supernatural occurrences. Multiple suicides appear to have left a frightening spiritual mark. Guests claim unseen hands have grabbed at them from beneath the sheets. Apparitions have been repeatedly sighted, including the figure of an infant whose cries can also be heard from time to time.

Years ago, a professor from Mexico visiting the University of Texas at Brownsville stayed at the hotel with his wife while giving a series of talks on colonial history.

"Welcome, Dr. and Mrs. Medrano," the concierge said as he handed them their key. "You'll be enjoying the amenities of room 101. Please give us a call if you need anything."

The space was ample enough, Mrs. Medrano opined, especially as they planned to spend as little time as possible cooped up inside. First on the agenda was a visit to the Gladys Porter Zoo, then they would be exploring the university grounds and other sites of historical interest before meeting local leaders and intellectuals for lunch or dinner each of the days they would be in town.

The first night they slept in the room, both were troubled by strange nightmares that they did not share over breakfast—angry voices and sobbing rang out in the darkness of their dreams, and formless shapes struggled all around their bed.

The couple tried to put forth upbeat, positive facades during the day's events, but an uneasiness had wedged its way into their hearts. An afternoon presentation at the museum eased their depression somewhat, and a lovely dinner with the mayor and his wife drew them completely out of their funk.

Yet their dreams were even more terrifying. Their beloved dead returned, pallid and terrifying, calling to them, urging them to join the growing family in the vast beyond.

When they awakened, drained and depressed, they finally shared their nightmares with each other.

"Something's wrong with this room," Mrs. Medrano said. "I can feel it."

Her husband looked warily around him. He could almost feel something watching them from the shadows of the room. "Perhaps. The place does make me a little uneasy. But there's only one night left. We can stick it out together."

Reluctantly, she agreed.

After Dr. Medrano's talk at UTB that evening, the couple had drinks with the university president, so they were both a bit tipsy and tired as they blundered into the room sometime after midnight. The professor had stripped down to boxers and undershirt when his wife gave a little shriek of fright.

"Sebastián! There's something under the bed!"

She backed against the wall, her blouse clutched in her trembling hands.

"A mouse?" Dr. Medrano asked. His wife had an acute phobia of all rodents.

"I don't know. Just come check!"

"All right, Mariana. Relax."

The professor walked toward the bed, his black dress socks sagging, and bent his knees to investigate. At that moment, a pair of pallid hands shot out and seized his ankles, knocking him flat on his back as they gave a tremendous yank.

"Oh my God!" screamed Mariana. "Sebastián!"

Dr. Medrano, dazed from hitting his head against the floor, felt himself being hauled ineluctably forward, his legs disappearing under the bed up to the knee. His fingers scrabbled uselessly against the carpet, finding no purchase as he was dragged closer and closer. The grip on his feet was resolute and so cold as to burn the flesh.

In seconds his entire lower body was hidden from view. He raised his hands and braced himself against the frame of the bed, straining against the determined and unending pull.

Cocking his head and cursing with the effort, Sebastián Medrano struggled to see what was under the bed. He could make out a darkness more absolute than night itself swirling there in the floor, and waves of frigid energy washed over his thighs.

"Mariana! Help! Grab my shoulders and pull!"

His wife shook herself from her astonishment, tossing aside her blouse and rushing to him. Hooking her arms under his, she yanked backward with every ounce of her strength.

The added effort helped the professor free one of his feet, and he leveraged it to thrust himself away from that inky whirlpool beneath the bed. His other ankle was released, and soon the couple were huddled together in a corner, panting and sobbing.

The respite was momentary. A thudding sound grew louder and louder, and soon it was joined by a horrible, muffled moaning. Then, rolling and flopping its way around the foot of the bed, a headless and limbless corpse advanced on the Medranos like some abominable, unspeakable worm.

The professor drew his wife to her feet with a violent tug and pulled her after him into the bathroom, slamming shut and locking the door.

"What . . . what the hell was that thing?" his wife gibbered fearfully.

"Shhh. Wait."

He pressed his ear against the door, squinting a little as he strove to make out sounds from the room.

"Sebastián! Talk to me. I'm really frightened, and I need you to talk to me."

He turned, leaning against the door. "I don't hear it anymore, thank God. Okay, look, I have no idea what's happening, but I think I know what that

Ghosts of the Rio Grande Valley

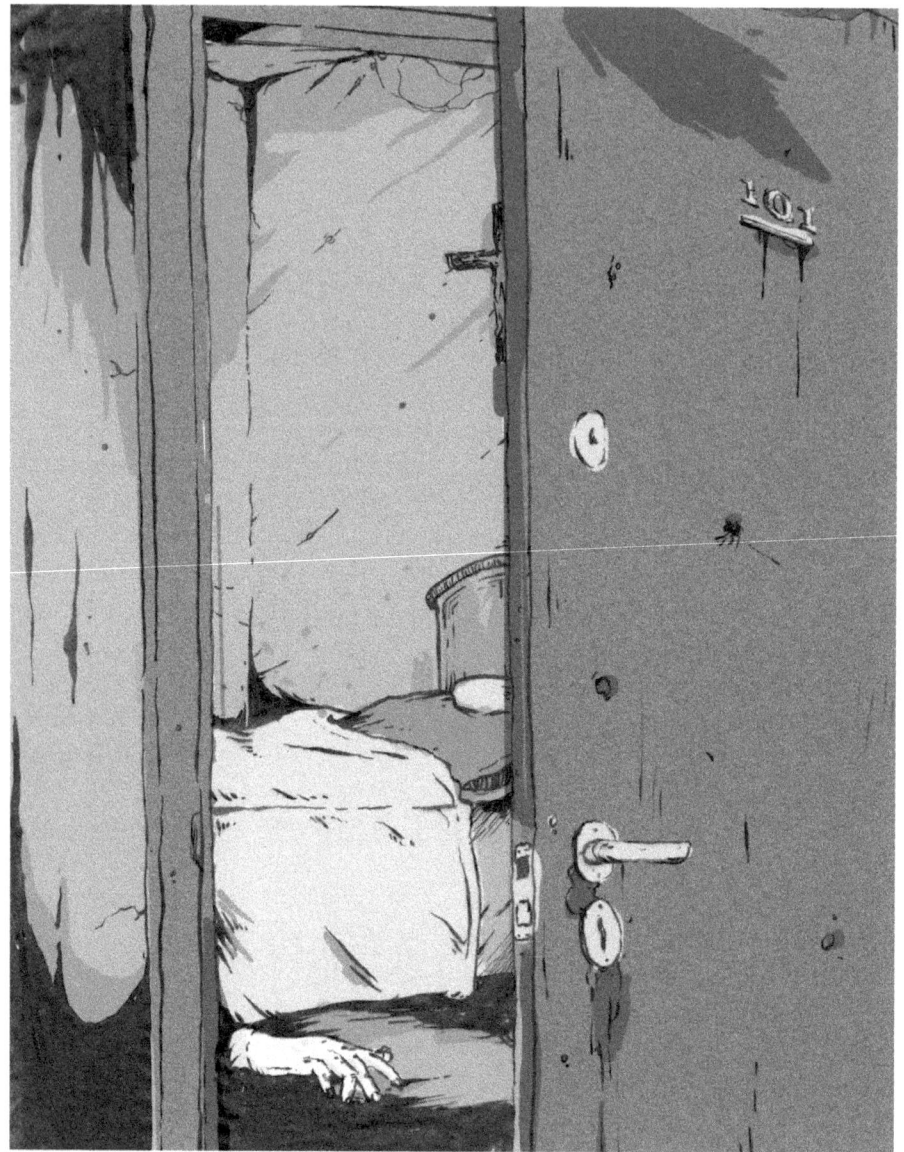

Ghostly hands emerge from beneath a bed at the Colonial Hotel. *José Meléndez*.

thing was. The Nahua tribes called it a *tlacanexquimilli*, 'human bundle.' It would supposedly appear to people, rolling around like that. Warriors proved their bravery by standing firm and not fleeing."

Mariana crossed herself devoutly. "You're not a warrior, Sebastián."

"No, I'm not."

"How can some Aztec demon be in Brownsville?"

"Ghost, not demon. I don't know, my love. Some Nahuas immigrated to this area when it was controlled by New Spain. Maybe one of them died on this land. Or maybe whatever force is at work in this room pulled the idea from my dreams."

Mariana shuddered. "So what do we do?"

"We'll wait here for a little longer, and then we'll run for the door. The concierge can call the police."

"Or a priest."

Loosening her hold on her husband, Mrs. Medrano turned to the sink, wanting to splash water on her face.

That is when she saw it—a bloated and bruised specter rising from the bathtub, its wrists bloody from gaping slits. It lifted its arms as if in supplication and stepped out, its right foot leaving a reddish-black smear of gore on the tile.

Its eyes were inhuman, round and wide like those of a nocturnal bird of prey. The professor wasted no time. He jerked open the door, ready to hurry out of the room. But toddling toward them came a baby, its skin blue and mottled, crying inconsolably. It was followed by its mother, half her face blown away by a gunshot wound.

A scream gurgling in his throat, Sebastián shoved the ghastly child aside with his foot and pulled his wife with him out of the room.

As they turned toward the door, frantic to escape, they were met by a massive owl, perched on the shoulder of a warrior whose fierce grin went dark with bubbling blood.

"Close your eyes!" Sebastián screamed. Sealing his own shut, he groped through the spirit being for the door handle, twisting the ice-cold metal and pulling with all his might.

The door opened. Husband and wife ran down the hall to the lobby, where the young man on duty that night stared at the half-naked, panicked couple and swallowed heavily.

"Let me guess," he said. "Room 101?"

The professor nodded, hugging his wife to him.

"Okay. Let me set you up in a different room for the rest of the night. I promise it'll be as far from there as possible, the suite on the top floor. No extra charge. I'll get your things and take them to you in a bit. You'll be fine."

He handed them the key with a trembling hand.

"Not the first time this happened, is it?" Dr. Medrano asked.

"No, sir. At least once a year. I don't know why we keep renting it out. The owner has had the room blessed over and over. Employees that have been here longer tell me several tragedies happened in there—suicides, mostly, plus a murder or two."

"Blessed by a priest?"

"Yes. And a curandera."

The professor shook his head. "That's not going to work. You need to find an Apache shaman. Have the owner check with El Calaboz. Could be someone there that can help."

The concierge narrowed his eyes. "Apache? Why?"

"The suicides were mostly young, weren't they? Twenties and thirties? Thought so. I'm betting all of them stayed at least three days or more."

Mariana, her arms crossed tightly across her chest, grimaced at her husband in anger and annoyance. "Explain yourself, Sebastián. What are you implying?"

"I think it's ghost sickness, dear. An Apache warrior died on this site years ago and was somehow desecrated. No proper burial, mutilation by Spanish or Mexican or Anglo foe. Maybe the construction of the hotel itself. Whatever the reason, he has been exacting his revenge through ghost sickness—he touches the souls of guests, and those susceptible become morbidly obsessed with death till they kill themselves."

"Ah. Let me guess; old folks like you and me are immune."

"Pretty much, yes. The preparation of corpses for burial was often performed by elders. Since we're closer to death, we're ironically less likely to yearn for it."

Mrs. Medrano sighed. "Ah, qué marido este. Well, it's your fault. You specifically asked for a room with history and local color. Serves me right for leaving it up to you. Next place we visit, we're staying at a Holiday Inn, do you hear me?"

The professor sheepishly nodded and led his wife to the elevator. As they waited for it to descend, he glanced back at the concierge, who was staring across the lobby at the darkened hallway with fear in his eyes.

"You'd better just stay there," Dr. Medrano called. "You're a prime candidate for ghost sickness, son. I'll be back down in a bit for our things."

The elevator chimed, and the couple got inside.

The young man let loose a shivering sigh of relief and crossed himself.

"Thank God," he whispered into the gloom.

4
THE WAILING WOMAN OF SAN BENITO

THE HISTORY

Straddling a jade-green oxbow lake between Brownsville and Harlingen on U.S. Highways 77 and 83, San Benito occupies the very center of Cameron County. Like many communities in the Rio Grande Valley, the town has its origins in a tract of land apportioned by the Spanish crown, in this case the Concepción de Carricitos Land Grant, awarded by King Charles IV to Bartolomé and Eugenio Fernández in 1789.

In the mid-nineteenth century, Judge Stephen Powers provided legal services to the Fernández family, receiving a sizeable slice of the grant in payment. Upon his death in 1882, his sons-in-law James Landrum and Benjamin Hicks were named administrators of his estate. Twenty-two years later, they teamed up with railroad developer Sam Robertson to establish what would come to be called the San Benito Land and Water Company.

In January 1907, the company carved its bit of the Carricitos grant up into lots and began selling, with an eye toward founding a town. After the men had tried out a few names, an employee of Hicks named Rafael Moreno came up with "San Benito" by combining Robertson's first name—Sam, which he reduced to "San"—with "Don Benito," a respectful Spanish version of Hicks's nickname, Benny.

Several places in San Benito are purportedly haunted. One of the most popular is the old abandoned San Benito High School. Built in 1930, the school served briefly as a hospital during World War II. Locals swear that late

A San Benito city street in the early twentieth century. *Library of Congress.*

The Resaca de los Fresnos Lake in San Benito. *Alexis Tran.*

at night the screams of the wounded and dying can be heard echoing down those empty halls. The campus was later renamed Berta Cabaza Middle School before finally closing in 1998, and neighbors claim that lights flick on and off as a uniformed old ghost patrols the rotting structure. At times, the gym is suddenly filled with the sounds of students playing basketball and laughing. Some have witnessed phantom of a little girl who died on the grounds wandering beneath the full moon, crying softly.

Even these ghastly apparitions, however, pale in comparison to the wailing figure that haunts the broad and beautiful oxbow lake that ripples with deceptive serenity at the center of town.

The Lore

The Legend of la Llorona, or the "weeping woman," has been widely told in numerous variations. It is an ancient tale, with roots in the beliefs of the pre-Columbian Nahuas, that collection of interrelated tribes now termed Aztecs.

Two sorts of apparitions seem likely sources. First are the *cihuateteoh*, or "divine women," fierce spirits of mothers who died during childbirth, considered fallen warriors by the Aztecs. They accompanied the sun as it descended each day into the underworld, protecting it from attacking forces. Their single-minded aggression, however, made it dangerous for people to encounter them at crossroads at night, when they might attempt to steal children or seduce men whom they would then drive mad. Also evocative of the weeping woman is the *zohuaehecatl*, or "maiden wind," a type of specter that wandered the night, keening beneath the stars.

It is possible that the modern Llorona legend has been influenced by a myth concerning the goddess Cihuacoatl, who lived at the bottom of Lake Texcoco, the Aztecs believed, appearing at night as a woman dressed in white. She was, according to the chronicles of the time, the harbinger of the conquest of Mexico. A woman's voice was reportedly heard crying out, "Oh, my children, their destruction has arrived, for we must soon depart!" Other times, the voice would cry in desperation, "My children, where shall I take you?"

The Spanish conquest of Mexico added new nuances to the old myth. The Spanish conquistador Cortés was aided immensely by the native woman christened Doña Marina, better known as "La Malinche." After her death, it was said that she was truly la Llorona, returning to grieve for having betrayed her own race by helping the foreigners to achieve domination of the Aztec empire.

Colonial storytellers shaped these disparate elements into a tale of tragic love and despair that highlighted the class difference between indigenous peons and Spanish aristocrats. The core story spread throughout Mexico and has lingered in the Southwest. Nearly every town near a body of water has its own version. San Benito is no exception.

The Legend

In the first decade of the twentieth century, on the outskirts of the newly established town of San Benito, the poor Bautista family struggled as many had before and have since. The mother died giving birth to her sixth child,

leaving the eldest daughter, Dafne, to help her father by taking on that role and raising her younger sisters and brother. She never once complained, and although she, of course, felt betrayed at times by the injustice of life, she seldom let her emotions distract her from her duties. She was generally a very good person, a bit short tempered, but kind to her family and neighbors and generous with all. Despite her poverty, she displayed the haughty beauty of a princess. Dafne, light-skinned and hazel-eyed, had the longest, most luxurious hair of all the women in her neighborhood and was, as a result, the envy of them all.

To help make ends meet, Dafne took on laundry work, hauling loads of clothes on the family burro down to the Resaca de los Fresnos, an oxbow lake with placid waters that served as a sort of irrigation canal. It was on the bank of this *resaca* that she was spotted one day by Lawrence Woods, a young Texas Ranger deployed to the Rio Grande Valley as part of a company defending against incursions from a Mexico in the grips of revolutionary war.

When Lawrence laid eyes on the girl, he was smitten at once. He tried to exchange a few words with her, but she rejected his advances, compelled as much by her upbringing as by the ethnic and class divides in her community. Lawrence, undaunted, drew away and waited for her to finish her labor. He then followed her home and, heedless of the poverty she lived in, decided that she would be his wife, no matter who objected. He began courting her, and despite the initial reservations of her father, Don Eladio Bautista, most of Dafne's family warmed to the idea of their betrothal, not only because the nuptials would improve their lot in life, but also because they genuinely liked Lawrence.

Dafne's thirteen-year-old brother, Ovidio, had become obsessed with the ideals of Villista guerrillas who were carrying out raids in the Valley. To him, Anglos along the Rio Grande were usurpers, and he was disgusted at the thought of his sister marrying a gringo, a member of the *Rinches*, or Texas Rangers, who so oppressed Mexicanos on the U.S. side.

"You're all traitors!" he shouted at his family. "Especially you, Dafne. Look at how those jackboots are arresting and even killing innocent people just because they speak Spanish."

"Don't be ridiculous," she argued. "Not all Rangers are bad. Certainly not Lawrence. You've seen how sweet he is with the little ones, Ovidio."

"It's just a trick. You'll see. He'll get tired of you soon, and then we'll all pay the price. When it comes time, though, don't worry. I'm man enough to defend this family."

The bank of the Resaca de los Fresnos Lake. *Alexis Tran.*

Lawrence also faced objections from his commanding officer and fellow Rangers. Even his own mother, a Houston socialite of Irish descent, had balked—via post—at the idea that her youngest son might marry a poor Mexican girl.

"You write of love," her final letter said, "but who has asked you whom you love? If the tart has you so bewitched, take her as your lover. I am fully aware that men do this. Your father himself, up to the very day of his death, dabbled in discrete liaisons. But marriage is social strategy, Lawrence. Love and desire are irrelevant. There are many lovely and eligible girls in high society, dear. Yet do as you will. Just understand this: if you marry that pauper, that strumpet, you will be disinherited. You'll not have a cent from me."

Lawrence tossed the costly paper on the company campfire, turning his back on his birthright for good. He and Dafne were joined in holy matrimony at the newly erected St. Benedict Catholic Church. In those first, joyous months, the newlyweds lived happily in their humble home, and Dafne cared for her family when her husband was on patrol, supplementing his wages by continued work as a laundress.

A child was born and then another. Boys, both of them, a perfect blend of mother and father. Lawrence doted on them when he could, but his time away grew longer and longer each year as bandit raids increased and the Rangers reacted with greater tyranny in response.

When news came of lynchings near Brownsville, Ovidio snarled with outrage and left his ailing father without a word. Dafne fretted at his absence, but he was nearly seventeen years old, able to make his own decisions, no matter how foolish.

Tensions along the border came to a head in January 1915, when Ranger Tom Whitfield arrested young Basilio Ramos, a Mexican customs employee who was purportedly trying to drum up support for an uprising among residents of the Valley. In his possession was a copy of the *Plan of San Diego*, a declaration by revolutionaries in Texas that called for Mexican Americans to rise up on February 20 and retake the entire American Southwest, executing all Anglo males over the age of sixteen. As lawmen scrambled to squelch a feared civil war, Lawrence found himself under the command of newly arrived Captain Henry Lee Ransom, a man determined to respond to raids with swift and gruesome retribution.

Violence spiked as President Woodrow Wilson increased military presence in the Rio Grande Valley to more than 100,000 troops. San Benito became a base of operations for soldiers from the Tennessee, Oklahoma and South Dakota National Guards. Together with the Texas Rangers, these troops

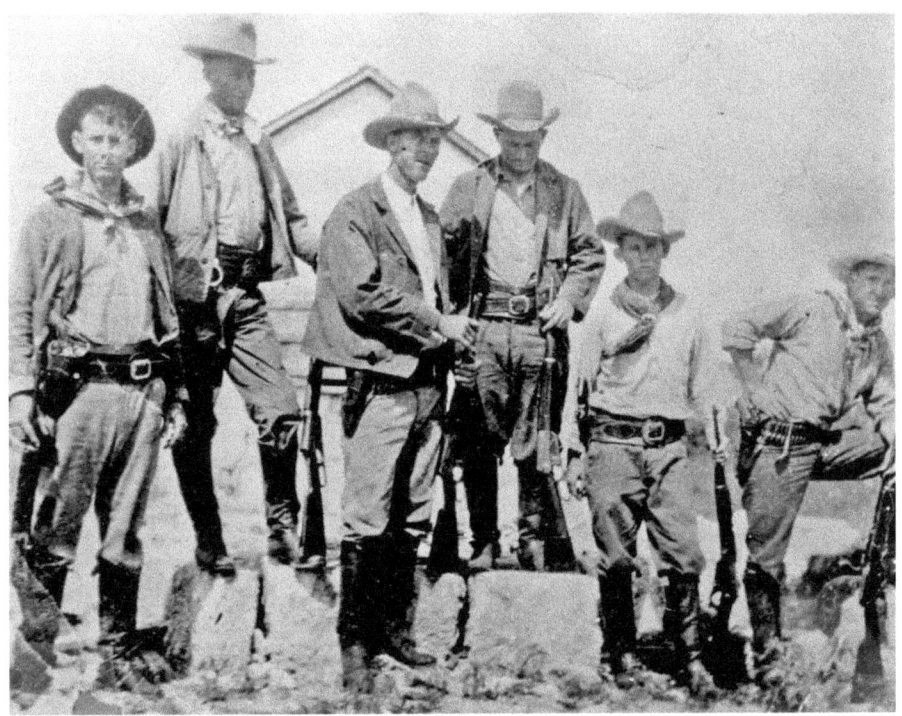

A group of Texas Rangers in the late nineteenth century. *University of North Texas Libraries.*

skirmished with rebels up and down the river. Lawrence was continually gone, and Dafne lived every moment with the fear that her beloved might be killed.

Her people were rocked by more and more aggression from Anglo lawmen. Hundreds of Mexican Americans went missing or were killed. The Spanish-speaking community withdrew even further from Dafne, treating her as a sort of pariah who had betrayed them all.

Lawrence showed little sympathy. "We don't know who's with the bandits, Dafne. The officers don't want to take risks. Anyone who seems like they're against us is going to pay the price. It's better if you just stay away from them. You don't have to do laundry. I can support us."

And he was off again on patrol.

Cold northern air had just begun to filter into the Valley when a neighbor came running to tell Dafne the news: bandits had used a wire cable to derail the night train to Brownsville, sending it plunging into a ditch just ten miles away, close to Olmito near Tandy Ranch. The engineer had died and two

passengers had been murdered before the attackers had made off with stolen goods, setting the cars aflame behind them.

But the tragedy was just the beginning of the horror for Dafne Bautista Woods. Her sister Gertrudis came to her, tears streaming, and broke her heart. Deputy Sheriff John Peavey, Gertrudis explained between sobs, had arrived at the train wreck and joined up with the Ranger company to which Lawrence was assigned. The men had begun to track the bandits, finding stolen property tossed aside along their escape route, down to where they had crossed the river into Mexico near the Villa Nueva Ranch. Frustrated that the revolutionaries had escaped, the lawmen had visited Tandy Ranch and, on Captain Ransom's orders, had taken ten Mexican Americans into custody on suspicion of collusion.

Four of them had been hanged on the spot. Six others were shot by Rangers as they attempted to flee. Among these was Ovidio Bautista, Dafne's only brother.

When Lawrence finally returned the following day, he found her inconsolable. What he had to say only worsened matters.

"I must leave, Dafne. Everyone's suspicious of me. My own brother-in-law, in cahoots with the bandits! Ransom is having me transferred."

"You expect me to just walk away from my family at a time like this?" she demanded between sobs.

"You don't understand. You're not coming. I've got to distance myself from you all."

"What? What about your sons? Where are you going?"

Lawrence paused, glancing away from her tear-streaked face. "Back to Houston."

"Houston? With your mother? But she . . . oh, my God, Lawrence. You're really leaving me, aren't you?"

"Look, when things calm down, I'll come back down to visit the boys. In the meantime, I'll send you money and things. But you and me . . . we just can't make it in this environment."

"I don't want you to send me anything!" Dafne sobbed, falling to her knees and clutching at his jacket. "I want a husband and father for my children. Don't do this, Lawrence. You don't need to be a Ranger. You don't have to abandon me and your sons. Look at them! What life will they have without you? We're as good as dead once you're gone."

"Don't be stupid," Lawrence replied angrily. "You'll have a perfectly fine life. Every material thing you could ask for I'll give to you."

"I don't want . . ."

"Damn it, don't you understand? *I was the one who killed him.* I had no choice. Ransom's orders."

And at that moment, as the world came apart around her, Dafne watched her husband simply put on his hat and leave without another word.

Despair and loss and rage swirled within her heart like an inescapable Charybdis. Her sons played and laughed, oblivious to the cruelty of their father. He was often gone. They thought nothing of it. She wept beside them, but they paid her no heed.

After a while, she wiped her eyes and nodded brusquely. Then she loaded up the donkey with two bales of clothing and set the squirming boys upon its back.

"Come on," she said with a strange smile. "Mamá has to do some laundry."

At the edge of the oxbow lake, she set them down on the sparse grass, looking listlessly at the surface in which the gray cerements of the sky were dully reflected.

I hate him. He took everything from me. Now I will take everything I can from him as well, she thought.

"All right. Time to get to work," she said aloud, calm like all suicides get before they take their lives. "But first, we're going to take a little swim."

"But, Mamá, it's too cold," said the eldest, a red-haired cherub of three and a half years.

"That's all right, m'ijo," Dafne replied. "The Virgin will keep us warm."

And she led her children down into the chilly water, held their heads under and blinked away tears as they slowly stopped struggling and passed into the arms of baby Jesus. Then she began wading deeper into the water to join them.

Lawrence, waiting for the train, felt something tug painfully at his chest. Leaving his meager luggage on the platform, he rushed to his empty home and then down to the Resaca de los Fresnos, where with a bereaved cry he discovered the bodies of his sons bobbing in the water.

There was no sign of Dafne's corpse. The authorities decided she must have fled to Mexico, a murderer like her bandit brother.

But no. There, at the bottom of the lake, Dafne was undergoing a metamorphosis. Her body sank into the muck, her raving soul trapped within by the shroud of suicide until the silent howl of her heart suffused every atom and transformed her into a rabid avenging ghoul that clambered from the wind-rippled water beneath a baleful moon. Lawrence, broken by loss and guilt, began to drink heavily to forget his pain, and though his mother reinstated him in her will before she died, he lost most of his inheritance gambling. One night, drunk and screaming at the heavens for

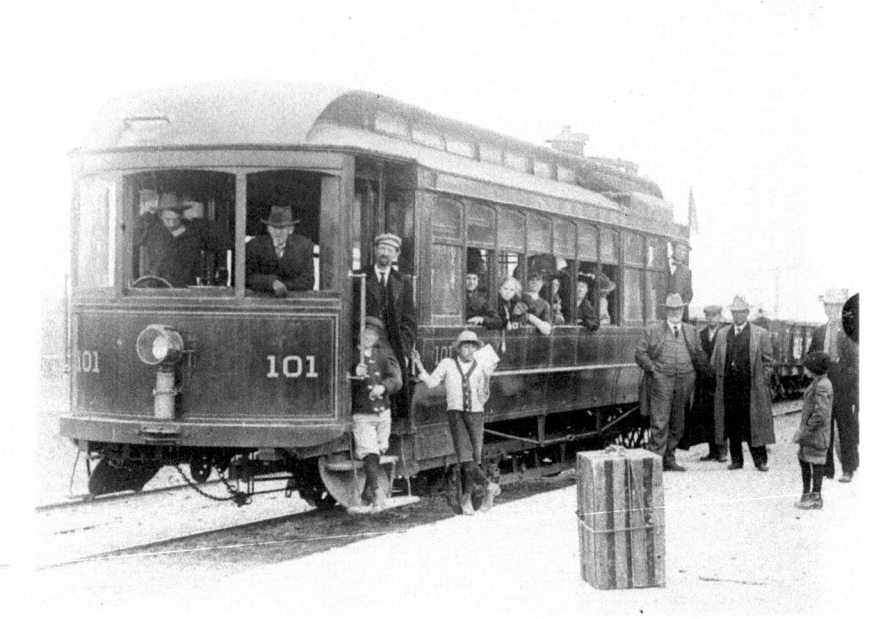

A railcar near San Benito in the early twentieth century. *University of North Texas Libraries.*

an explanation as he stumbled along the tracks near Olmito, Lawrence was struck by a train and killed instantly.

Once their long grieving was at an end, the four younger Bautista girls took over Dafne's laundry work. Their father's illness and grief had ruined him, so they accepted as many clients as possible, scrubbing at clothes well past dusk at the shore of the lake.

The youngest two often grew weary and would wander along the bank, plunking rocks into the water and singing children's songs while their elder sisters beat out stains beneath the stars. One evening, as they wandered farther than ever before, they came across a strange figure standing in their way, dripping water, hair tangled and wild.

It was a woman, pale as the moon. She was weeping uncontrollably, sobs hitching violently in her chest. As her hollowed eyes fell upon the girls, she lifted hands like claws, tipped in the long and pointed nails of the dead.

"Where are they?" she howled, her face twisting with rage and sorrow. "WHERE ARE MY CHILDREN?"

Then, rushing forward with spectral speed, she seized the sisters she no longer knew and plunged into the lake with the girls in her arms.

San Benito's Llorona. *José Meléndez*.

Those deaths were not the end. They were only the beginning. Even now, if you walk alone in the dead of night, you might happen to see either Dafne or Lawrence. At least, you may hear their sobbing and screaming. Lawrence has been condemned to walk the railroad tracks of the Valley, forever in search of his wife. Dafne still wanders along the shores of the lake, looking for her children as she weeps, forever inconsolable. Neither of them will ever find what they are looking for, but if la Llorona happens to find you there at the resaca's edge, she just might mistake you for one of her children and drag you down into the watery black depths.

5
THE HARLINGEN INSANE ASYLUM

THE HISTORY

At the crossroads of U.S. Highways 77 and 83, just thirty miles from the coast, a lawyer founded a town with a very strange name—Harlingen—whose namesake is a coastal community in the Netherlands. Called the "Chief" because of his indigenous features and long hair (which he attributed to Choctaw ancestry), Leonidas "Lon" Hill strategically selected this location—then the junction of two railway lines—with an eye toward establishing a center of industry, distribution and shipping. For a time, his small settlement was known as "Six-Shooter Junction" because the only Anglos who lived there were Texas Rangers, officers of the border patrol and the Hill family, who housed the law enforcement personnel in their own barn and corrals. Though Lon Hill was disparaged as a lunatic for wanting to establish a settlement in the midst of an area prone to flooding, within a decade Harlingen had grown into a vibrant and essential part of the fabric of the Valley.

Of course, creation is continually balanced by destruction, and the tragedies of all growing towns were visited on Harlingen. To this day, residents report inexplicable apparitions tied to the sites of uncommon death. Dishman Elementary teachers, for example, tell of a student who in the 1960s was beaten to death by a classmate in the girls' restroom. Dedicated instructors working late to plan the follow day's lesson have heard whimpers and cries coming from the last stall as lights flicker and coldness spreads. Memorial

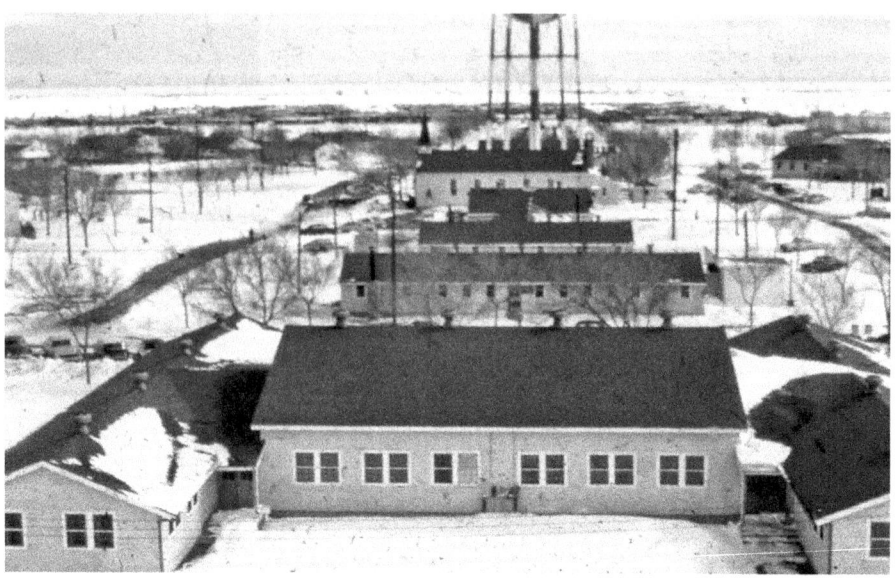

The Harlingen Air Force Base where the asylum was established. *Wikimedia Commons.*

Middle School, staff and students affirm, is also haunted by two girls who died there under mysterious and questionable circumstances. Custodians tell of seeing ghostly forms floating sadly in remote corners of the building.

A couple of roads themselves are reportedly haunted. On Matz Street, a little girl wanders, sobbing with her head down, seeming lost. She will not reply when spoken to, though she will occasional look up at anyone who has drifted close, despair filling her eyes before she suddenly vanishes. Nearby, on Shirley Street, another young girl haunts the house that fronts the canal where she apparently drowned. Stories tell of a mysterious woman in white awaiting her at the edge of the water.

But when we think of hauntings in Harlingen, one site commands a sense of real awe and fear—the so-called Harlingen Insane Asylum.

The Lore

Always forward-thinking, the leaders of Harlingen began in the late 1930s to attempt to draw attention to their town as the site of a commercial airport center. These efforts led to interest on the part of the U.S War Department,

The ghost that haunts the asylum. *José Meléndez*.

and in 1941, the government committed to establishing the Harlingen Army Air Field on the outskirts of town. One of the buildings erected on the base was a hospital that served the soldiers and pilots living and training there.

When in 1962 the State of Texas began searching for a place to provide care for people of the Rio Grande Valley who had been released from the care of the mental health wing of the San Antonio State Hospital, it hit upon the idea of leasing space at the airfield, by then known as the Harlingen Air Force Base and slated for closure by President Kennedy. The idea was to eventually move into the airbase hospital.

Until the base completely shut down, however, the Harlingen Adult Mental Health Clinic, as it had been named, was temporarily housed in a line shack near one of the runways. Six staff members cared for patients in that cramped space until the following year, when services were moved into the hospital. The Harlingen State Mental Health Clinic—as it was renamed in 1965—provided outpatient care to adults with mental health or addiction issues. Within a few years, a wing with twenty beds was added so that people with severe, around-the-clock needs could be properly attended to.

Legend has it that not everyone got better. In fact, some in the community believe that a few patients died, leaving their restless souls to shamble around the grounds as they once did in life.

The Legend

The Vietnam War produced more than one kind of casualty. Petty Officer Tomás Cortez was on his first tour of duty aboard USS *McKinley*, the flag ship of the Seventh Fleet Amphibious Force, when he received a Dear John letter from his lover Jacob Franklin. Jake could not bear the wait, the doubt, the worry. Better the two break off their relationship, he said. Better for them both.

Tom dealt with the news very badly, getting drunk while on duty and making ridiculous errors in the personnel reports he typed up as a result. But his biggest mistake was coming on to Seaman Bobby Lezama, a burly young Cuban whom Tom found very attractive. Unfortunately for them both, Chief Petty Officer Knab walked in on their tryst.

This was the U.S. Navy in the year 1967. Homosexuality was not openly condoned, and Knab was especially intolerant. Both men were given dishonorable discharges and sent home.

Twenty-one-year-old Tom found himself living with his parents again in Mercedes, Texas. It did not take long for them to discover the reason for their son's return, and the devout Catholic couple was predictably appalled. Tom's elder brother—married and father to three toddlers—threatened to give him a beating if he did not get some help for his "condition." In order to avoid problems and have the use of his father's car, Tom agreed to meet regularly with the family's priest.

Grappling with the divide between his own happiness and the sin his loved ones condemned him for, Tom began slipping into depression and drinking to excess. One day, he showed up at Our Lady of Mercy in such a state of inebriation that Father Kaler had to call his parents to pick him up.

His family members were unanimous—Tom had too much time on his hands and needed gainful employ. They gave him one month to find at least part-time work.

One day, while out looking for job openings, Tom happened to drive by the restaurant where Jake worked. His chest aching with nerves and longing, he decided to stop and say hello.

Jake smiled, wiping his hands on his apron. "Hey, it's good to see you, Tomás. Wait for me out back, yeah? I've got a break in about ten minutes."

Leaning against the alley wall, they shared a cigarette and got each other caught up. Jake had dropped out of Pan American College to take care of his ailing mother, and Tom was sorry to see the young man's dreams put on hold.

"Oh, man, that's too bad," Jake remarked when Tom had finished relating his own bad luck. "Tough enough to make it in this messed-up society as it is, without your parents breathing down your neck."

"Yeah, well, I should've known better."

Jake passed Tom what remained of the smoke, and their hands touched for a moment. They both felt the jolt—the spark they had once felt was still glowing. By the time Jake had to go back on the clock, they had arranged to meet up that weekend for drinks.

Before long, the two began seeing each other seriously again. Jake helped Tom find work in his uncle's insurance office, and the Cortez family relaxed in their worry about him. Life settled into an idyllic, if secretive, routine. There were few places in the Valley for gay men and women to be themselves, but they existed nonetheless, small bastions of hope and freedom in the heart of a severely conservative wilderness.

The couple discovered their attraction was deepening into love. They began to make tentative plans, to think about leaving South Texas to seek belonging elsewhere. Giddy with the future, they became careless.

One night, Tom slipped into old habits and had entirely too much to drink. Jake insisted on taking his keys and driving him home. It was late when he helped his stumbling lover in through the back door of his parents' home and into his bedroom.

"Stay with me," Tom slurred. "Just a little while."

Shushing him before anyone was awakened, Jake agreed.

Rough hands pulled Jake from the bed a few hours later. As he opened his eyes, he saw Mr. and Mrs. Cortez, faces twisted in anger and disgust, spitting horrible insults. Mrs. Cortez rounded the bed and slapped her son awake.

"Desgraciado," she wheezed. "How dare you bring him into this house? Ay, dios mío, such perversions under this decent roof!"

Jake pulled himself to his feet. "It's not what you think, ma'am. We had a little too much to drink, and I just stayed to sleep it off."

Hand to his reddened cheek, Tom sat up and eyed his parents with fury and shame. "Can't you knock? This is my room, you know."

"This is our house," his father gritted. "And you know the rules. You swore you were getting help."

Tom shook his head. "I don't need help. I need Jake. I love him."

Mrs. Cortez crossed herself with a moan, looking up to heaven.

Mr. Cortez turned to the young Anglo man. "You need to leave. Now."

Jake looked at Tom, gesturing for him to be calm. But it was too late.

"Then I'm leaving, too," he said, yanking the sheets away.

"No," his mother said. "Not until we talk. I'll call Father Kaler. He'll help you get this demon inside you under control."

"The hell he will!"

As Jake still hadn't moved to leave, Mr. Cortez began to force him from the room. "I said get out."

"Tom, I'm going," Jake called as stepped through the door. "Don't freak out. Let them calm down. We'll figure this out later."

Rubbing tears from his eyes, Tom nodded. "OK, OK. See you soon."

Jake left the house, staring back over his shoulder and shaking his head in dismay. It was a hard world. But somehow, he swore, the two of them would find happiness.

The Cortez family had other plans. Colluding with their elder son and their priest, Tom's parents had him committed to the Harlingen State Mental Health Clinic, which had just added twenty beds in order to allow patients with extreme needs to remain in the institution around the clock.

Tom had to be dragged bodily inside. He railed against the orderlies. He spat out the tranquilizers. Over the course of a week, he tried every deceit imaginable to catch his captors off guard and escape.

Nothing worked. The doctor and nurses refused to listen to his pleas. The orderlies strapped him down at night and forced mind-numbing drugs down his throat during the day. Existence became a haze except for moments of frightened clarity.

"I have to see him!" he would scream at such times. "Even if it's just to say goodbye!"

Electroshock therapy was next, but not even the spasm-inducing jolts of energy could erase his bereft longing.

Finally, after a particularly vicious outbreak, Tom was strapped into a straitjacket and placed in solitary confinement. Broken by despair, mistreatment and antipsychotic drugs, he managed to struggle free of his restraints and use the garment to hang himself.

The orderly who entered later that day to feed him found the former sailor dead.

As Mr. and Mrs. Cortez were receiving the tragic news by phone, Jacob Franklin was smoking a cigarette in the alley behind the restaurant at that magic hour of the day right before the sky edged from pastel pink and blue

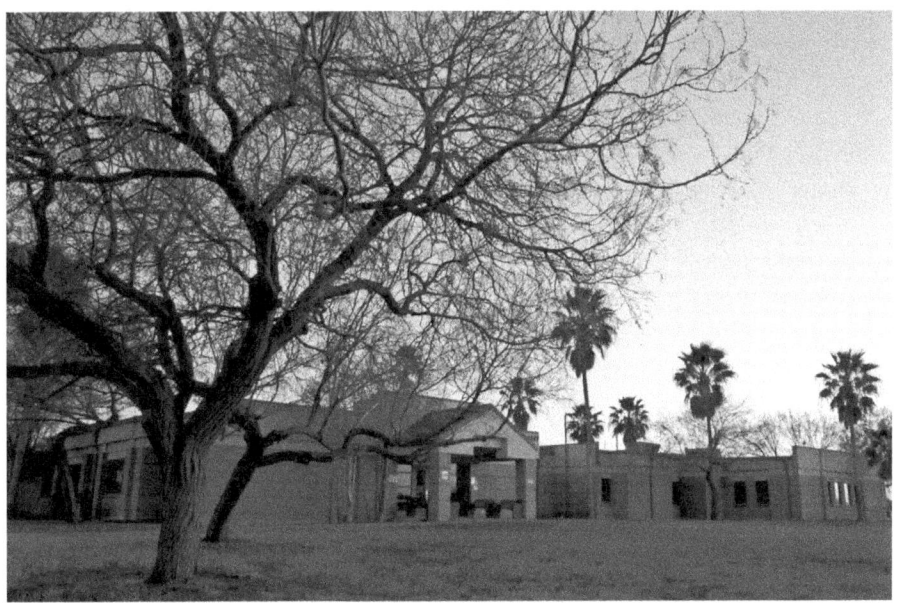

The Harlingen State Mental Health Clinic today. *Alexis Tran.*

to the darker shades of evening. He could not understand why Tom had not contacted him. Every attempt he had made at calling or dropping by the Cortez home had ended badly. Tom's elder brother had threatened to smash his face in if he did not leave them all alone.

Jake would not believe the lies they told him, though, about how Tom felt nothing for him and was getting professional help to rid himself of his sinful habits. They had made vows, silly little promises whispered under the moon. They were bound to each other.

Sighing heavily, Jake turned to go back inside when a silhouette caught his eye. Squinting against the failing golden light, he saw that it was Tom.

"Oh my God!" he cried, rushing toward his lover. "Where have you been?"

"Stop, Jake." The voice was like a tortured echo. "I don't have long."

Tom's eyes were full of darkness. Jake realized he could see the cross street behind the man, misty and out of focus, but visible all the same—through his insubstantial body.

"What's happening, Tom? You're scaring me."

"They locked me away. Told me I'd never see you again. Pumped me full of drugs. Forgive me, love. There was no choice. I had to see you one last time."

There were ligature marks on the fading flesh of his neck. The truth was clear. Tomás Cortez was dead. This was his ghost.

"Oh, you stupid, stupid boy. What did you do? What did you do?"

"I love you, Jake. It was worth it, just to look into your eyes. Even if we can't touch. I love you."

Then the phantom was jerked backward with a rushing sound, and the alley was empty once more.

Jacob Franklin fell to his knees and sobbed his heart out as night slowly fell.

They say that Tom was not the first or the last to die in that place. Others took their lives as well or lost them at the hands of people charged with saving them. Now those souls, abandoned and forgotten, wander the grounds with aimless rage. If you slow as you drive by on a moonlit night, your windows down, you can hear the ragged chorus of their desperate screams, echoing eternally.

WILLACY COUNTY

6
SAN PERLITA AND THE DEVIL'S LAGOON

THE HISTORY

The Agostadero de San Juan de Carricitos land grant, awarded by King Charles III to Don José Narciso Cavazos in 1792, was the largest territory apportioned by Spain in South Texas. Its 600,000-acre extension encompassed nearly all of modern Willacy County. In 1793, the Cavazos clan took up residence—part of the condition of the grant was that it be permanently settled as set forth in Spanish law.

After Mexico won its independence, it sought to strengthen its northern borders through colonization laws that did not always favor the heirs of the original grantees. Land granted by the short-lived Republic of Texas complicated matters further; under the 1848 Treaty of Guadalupe Hidalgo, the state of Texas recognized the validity of the original Spanish and Mexican grants, but eager developers tried every trick in the book to cheaply wrangle land from the Mexican American families controlling those properties.

In 1881, Richard King and his partner Mifflin Kenedy won a lawsuit they had filed against the Cavazos heirs under the pretense that the land granted to the family had not been permanently settled as stipulated by Spanish and Mexican law, which nullified the original agreement, making the territory state property. The court's decision allowed the sprawling King Ranch to purchase the land and resell parts of it at a massive profit. Some twenty-three thousand acres went to the Gulf Coast Irrigation Company to create the Gulf Coast Subdivision, which would later be reorganized into Willacy County.

In the mid-1920s, Charles R. Johnson and W.G. Hecht founded a development company in order to establish on the southernmost outskirts of the King Ranch the little town of San Perlita, named for Pyrle, Johnson's wife, who oversaw the site's landscaping in 1926.

By the time the Great Depression hit the Rio Grande Valley, both the highway and the Missouri Pacific Railroad had reached San Perlita, which in 1933 housed more than 150 residents and eighteen businesses.

None had much love for the hegemonic presence of King Ranch just north of them, hording its bounty in such lean times. And the company that controlled those vast lands kept a watchful eye out for poachers seeking to ease their misery on the other side of the barbed wire.

THE LORE

Though it does not border the Rio Grande, Willacy County is a coastal region dotted with lagoons and marshes that tend to flood during the rainy season. The Mexican settlers of the area brought with them deep-rooted beliefs about water that stem from the indigenous religions of pre-Columbian Mesoamerica. Rivers, lakes and *cenotes*, or sinkholes, were considered sacred

The lagoon today, dotted with wind turbines. *Alexis Tran.*

places by the Maya and Aztecs, borders between our world and the region of the dead that spirits could cross at particular moments, usually during the evening or at night. Human souls traveled to the underworld upon death, it was believed, through these aquatic passageways.

In a similar fashion, many bodies of water in South Texas are said to be haunted by ghosts of some sort, from wailing specters to silent revenants. One of the most famous of these locations is a small lake near San Perlita known informally as the Devil's Lagoon.

The Legend

In 1850, El Sauz Ranch had not yet been acquired as part of the empire Richard King built when he wrangled large chunks of the San Juan de Carricitos land grant out of the hands of its rightful heirs. The Missionary Oblates of Mary Immaculate had spent the better part of a year establishing a circuit throughout South Texas, shoring up the folksy Catholic faith of ranch communities with a visit from an Oblate priest every six weeks.

The story goes that a young man and woman living on the El Sauz Ranch decided to be joined in matrimony at the next scheduled stop of their circuit-riding priest. Their parents made arrangements for a ceremony at the ranch house, and on the auspicious day, a procession of wagons and carriages set out, transporting the wedding party.

Partway through the journey, the driver of the coach that contained the bride, the groom and their parents pulled off the accustomed trail, taking a shortcut that passed by means of a rickety wooden bridge over a deep lagoon. The passengers called out in alarm at the route, only to be ignored by the driver, who whipped the horses into a flat-out run. Halfway across, the bridge suddenly collapsed under their weight, plunging them into dark water that both pressed against the doors and poured in through the windows.

The bride and groom, realizing this was the end, embraced their parents, kissed each other and vowed eternal faithfulness in whatever existence lies beyond the threshold of death.

Driver, horses, passengers—all of them drowned. The coach was never recovered.

The Missionary Oblates of Mary Immaculate were called back to France not long after the tragedy. They would not return to the Rio Grande Valley until March 1852. By then, Richard King had ridden through El Sauz Ranch and found it utterly deserted.

The Devil's Lagoon. *Alexis Tran.*

The reason for the collapse of El Sauz remain a mystery. However, the locals swear that on certain nights, under the light of an autumn moon, the spirit of the driver spurs the ghostly steeds with a hellish whip and the carriage emerges from the depths, bearing its dead passengers into the world of the living once more. Some people in and near San Perlita claim to have witnessed the ghastly apparition yet escaped with their lives.

Others have not been so lucky.

During the waning days of 1936, the depths of the Great Depression, San Perlita—like most communities around the nation—was at its economic and emotional nadir. One of the coldest winters on record had been followed by a deadly heat wave and catastrophic tropical rainfall, worsening the misery of the locals.

Two miles north of town lay the Blanton beet farm, fields fallow and brittle like the hearts of the meager family that worked it: Luther and Myrtle, hardened folk in their fifties, and their only remaining son, John, whose emaciated and weathered form appeared older than his twenty-four years.

Luther and John were expert hunters, and they had kept themselves alive during the family's darkest days by tracking prey through the chaparral. As their farm abutted the El Sauz division of the sprawling King Ranch, these

forays for food often took them across the property line and into heated conflict with fence riders who patrolled the edges of the vast ranching empire. Despite their reputation for trespassing and poaching, the men were generally seen as harmless and had no real enemies to speak of.

On the morning of November 18, Myrtle made it clear to her husband that they would not make it through the next few days on their remaining provisions. Nodding, Luther grabbed his twelve-gauge shotgun. John needed no urging to take up his own sixteen-gauge Riverside pump. The two of them set out, silently agreeing to bring back a brace of ducks, as it was the season for such waterfowl.

Around noon, having had no success near the pond on their own property, father and son slipped through the barbed-wire fence to try their luck in the Sauz division of King Ranch. They spent several hours on the trail of a white-tailed doe but lost her deep in the brush.

Distant gobbling sent the men tracking wild turkeys, but nothing came of their search.

"Enough of this," Luther muttered. "Let's double back to the lagoon."

The sun was low in the western sky, the almost transparent semicircle of a half moon hanging above it by the time they reached the reedy banks. The slow-moving rains that had fallen in September had swollen the lagoon well beyond its normal edges, and leafless shrubs kinked their gnarled branches into the air from the shallows. Among these denuded limbs, a flock of mallards bathed and fished.

Nodding to each other, father and son lifted their shotguns to their shoulders.

"*Alto ahí*," a voice called out sternly in Spanish from behind them. Luther and John swiveled about to find an old man standing a dozen feet away, his features obscured by a straw hat. He gestured at them, a cigarette held loosely between his fingers.

"You the Blantons?"

"Yup," drawled Luther. "You with the ranch?"

"*Así es*. Yes. Been waiting here a while. Figured you'd come. Got a message. We're about fed up with you all cutting over the fence and poaching our game."

"Your game? Son, you're just a hand. All you *kineños* are. Ain't no 'our' about it. King family claims everything on this ranch, but they got to hire guns and Mexicans to protect it. Now, from where I stand, we two have guns, and you ain't got nary a knife on you. So how's about you just turn around and head back to your shack and such. We'll shoot us a pair of drakes and be on our way."

The shadows of surrounding mesquites stretched long across the lagoon. The golden hue of sunset deepened into dusk. The old man tilted his head and looked up at the moon, resolving into solidity against the purpled heavens.

"*Bien.* Seeing as how you're too damn stubborn to respect boundaries, I reckon you won't mind crossing this next one, neither."

Pointing at the water, he shouted, "*Auriga maléfico, ¡Acarrea estas almas condenadas en tu carruaje demoníaco hasta las mismas puertas del infierno!*"

As one, the flock of mallards lifted into the air, squawking in dismay. Neither father nor son hesitated a moment: they fired simultaneously, sending two drakes tumbling into the brush.

Luther gave an uncharacteristic grin. "Thanks, señor. While I don't mind killing no sitting ducks, on the wing is best."

John nodded his agreement as he began walking through the mud to retrieve the birds. "That's right. More sportsmanlike."

Movement caught the younger man's eye. Glancing into the water, he glimpsed strange gleams just below the surface, and deeper down shimmering forms coalesced and dissolved.

"You see that, Pa?"

Luther stepped closer.

"Some sort of fish," he mused. "Twilight glinting off scales."

"I don't know." John leaned toward the lagoon. "What's that sound? Like muffled laughter or screams . . ."

Without warning, water shot up in a hissing geyser, sending the two men stumbling backward. John tripped and fell flat on his back as clambering from the inky lagoon came the bony forms of dead horses, strips of rotting skin ribboning their muzzles and ribs. They neighed viciously as they pawed the air, dragging a waterlogged carriage from the depths. On the driver's bench sat a cadaveric fiend with glowing red eyes and a rictus of maddened glee; it wielded a fiery whip, lashing the skeletal steeds. From within the coach came the harrowing screams of the drowned, a chorus of damned, despairing voices.

John had just dizzily regained his feet when the demonic driver drew that macabre cabriolet past the edge of the lagoon, its wheels glowing green as they sliced through the loam. The doors opened, and the ghosts of both bride and groom emerged for a moment to embrace above the ragged roof.

As father and son stared in shock at the ghastly reunion, the flaming whip snapped out at first one and then the other, wrenching them into the carriage like fish snatched from a flowing stream. Then the revenants pulled apart, the bony hands of each lingering a moment on the other's tattered

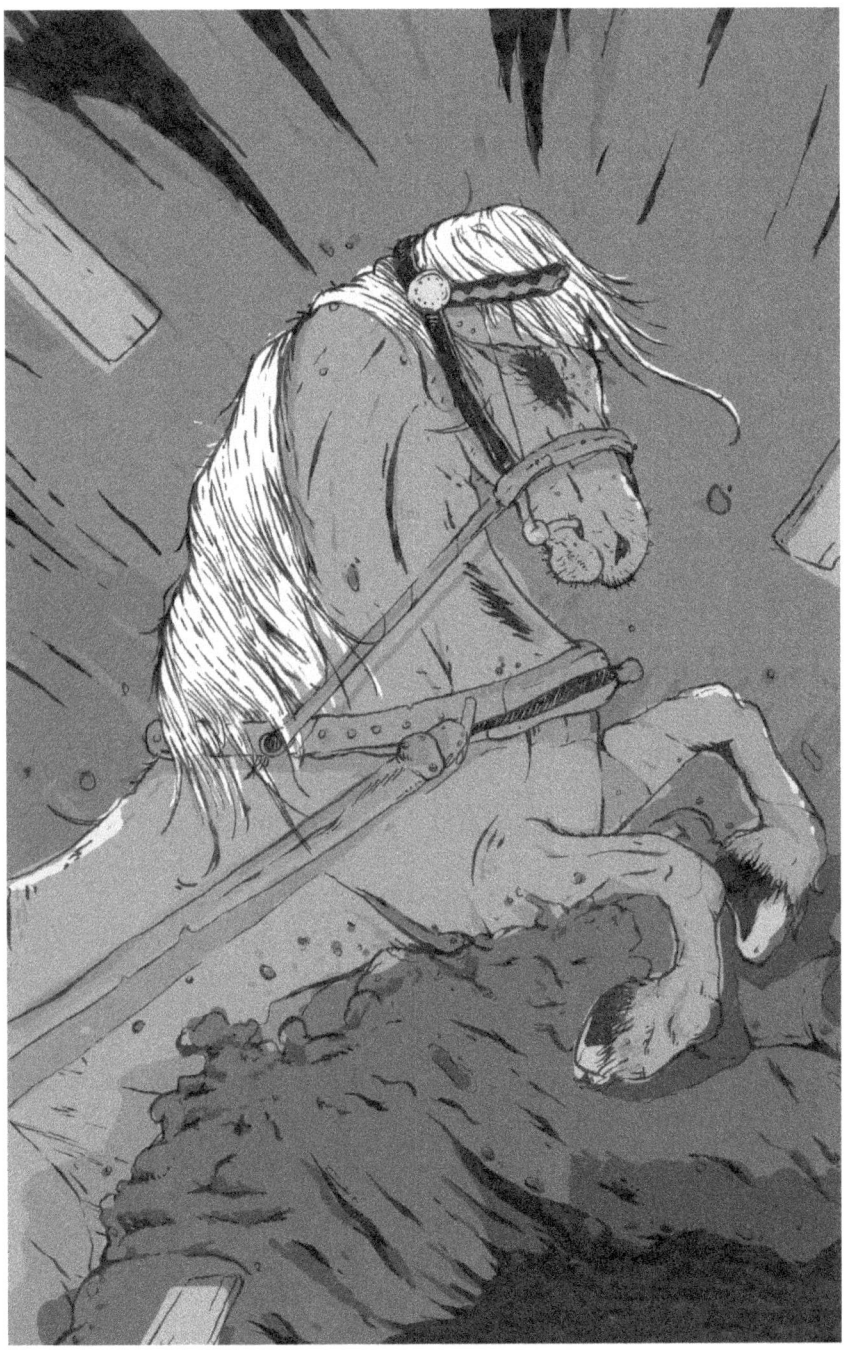
One of the phantom horses at the Devil's Lagoon. *José Meléndez*.

clothes, and they swirled their way back inside the cabriolet, slamming shut the doors on John and Luther's incipient screams.

A ghoulish laugh upon its bloody lips, the driver urged the phantom steeds into the air once more and with a final crack of the whip plunged its damned passengers into the Devil's Lagoon.

The waters stilled. The phantasmagoric glimmers faded.

The old man dropped his cigarette upon the mud and slowly walked away.

Mrs. Blanton heard the two shots around sundown and guessed that her husband and son had killed some birds. When her men did not return at dark, Myrtle Blanton grew concerned, keeping a tense vigil all night. At first light, she set out for Raymondville to learn whether Luther and John had been arrested for trespassing.

The authorities had not seen either man. After a few phone calls, it became clear that they had simply gone missing. Suspecting foul play, the Willacy County sheriff organized a search party. They found tracks at the lagoon that matched the size and style of the boots the Blantons wore, along with a shotgun shell and cigarette stubs. Beyond that, the sheriff reported, there was nothing more. Just footprints leading to the lagoon.

Neither Myrtle nor the community was satisfied with this conclusion. The Texas Rangers were called in, but they discovered that the previous lawmen had trampled all through the mud, destroying most of the evidence through negligence. Rangers interrogated employees and owners of the ranch, but no further information was forthcoming, and the administration took offense at what they felt were insinuations of criminal mischief on their part.

Thanksgiving came. Myrtle, despite her devastation, rejoiced at the generosity of the community, as neighbors and strangers showed up at the farm with wild turkey and trimmings, determined not to let her pass the holiday alone.

Yet as the outpouring of solidarity faded, Mrs. Blanton despaired at the lack of progress on the case. Constable Ernest Oakes of Sebastian received a tip by phone on the supposed resting place of the men's dead bodies, but his expedition deep into the brushland revealed nothing. The Texas Rangers did what they could: Captain William McMurray conducted an investigation up and down the state, while Ranger Ernest Best pursued leads as far off as Canada and California based on information coming in that claimed the Blantons had grown weary of the fruitless and grueling work of beet farming, choosing instead to leave the state. Ranger captain Alfred Allee, who headed up the South Texas area, had reached a similar conclusion

after a witness swore that he had sold gasoline to two men resembling the Blantons as the two headed north.

None of this sat well with Mrs. Blanton, who was convinced that her husband and son had been murdered for trespassing on King Ranch. One of the first Texas Rangers on the scene, Captain Bill McMurrey, concurred with this theory, affirming that Luther and John had either been killed at the lagoon's edge or driven away from there to be murdered elsewhere. A Colonel Carmichael with the Department of Public Safety threw his weight behind the claim, confident that someone would eventually come forward to dispel the widow's doubts.

At night, Myrtle would stand at the edge of the farm, gripping one of the wooden posts of the fence that her men had crossed to meet their doom. Beneath the waning autumn moon, she imagined she could hear their final groans of pain, wafting whisper-thin upon the cold, dark air. She had lost her two eldest boys to the slaughter of the Great War, their broken bodies tumbling in some distant field of France. Only justice could make this final bereavement, this unmooring from the world, somewhat bearable.

In early December, the widow received a visit from one of the men who first entered the King Ranch property and searched for Luther and John right after they had disappeared. Unwilling to give his name—being related to a sheriff's deputy as he was—the man told Mrs. Blanton of mysterious tracks the posse had discovered there in the mud beside the lagoon, tracks which had run a short distance and then inexplicably vanished.

"We were told to rub them out, ma'am," the stranger confided. "They weren't no tire tracks, more like the ruts that the wheels of a carriage leave. But there weren't no way for a carriage to be there. It just didn't make no sense."

Furious, Mrs. Blanton confronted the authorities with this new information. She was certain now that someone had ambushed her son and husband at that lagoon, making them walk to a waiting carriage before spiriting them away to a distant and desolate spot to do the dirty deed.

The press picked up on this story, demanding action, and the locals of San Perlita and Raymondville were worked into such a fevered pitch that they threatened to tear down the fence and burn King Ranch to hissing ashes.

But no evidence was found. The case went cold. Only a silent cabal knew the truth.

Meanwhile, deep in the hellish heart of the lagoon, the Blanton boys' long agony had only just begun.

7
THE LONELY GHOST OF LYFORD

THE HISTORY

The small town of Lyford hugs Highway 448 where it overlaps 77, along the Missouri Pacific line between Farm Roads 498 and 1921 in central Willacy County. Like San Perlita, it, too, once formed part of the Agostadero de San Juan de Carricitos land grant, which fell into the empire-crafting hands of Robert King in the late nineteenth century.

On Independence Day 1904, the St. Louis, Brownsville and Mexico Railway arrived on land controlled by the Gulf Coast Irrigation Company—thirty-four thousand acres purchased from the King Ranch. The property was dominated by a lake known informally as Laguna del Cómo Se Llama, or Whatchamacallit Lagoon. As a result, locals took to calling the community that sprang up there the Cómo Se Llama area.

William H. Lyford, attorney for the Chicago and Eastern Illinois Railroad, fostered the growth of the community. Between 1904 and 1906, it transformed into a tent city that residents called Lyford. The attorney eventually set up the Lyford Realty Company, filing for an official plat for the town on March 19, 1907, in Cameron County. The first public building—Pioneer Hall—was built that year to house a school, church services and community meetings. A post office and the Lyford Hotel followed on its heels.

Lyford's connections with the railroad made it easier for him to entice and transport settlers by rail from Illinois, Indiana and Iowa. In those early days

The overpass viewed from below. *Alexis Tran.*

of Lyford's history, Mexican Americans were soon segregated, with town leaders agreeing to set up an entirely separate town to ostensibly allow them complete self-governance.

When the Mexican Revolution was at its height in 1913 and 1914, National Guard soldiers and Texas Rangers were sent to Lyford to quell any local uprisings and to stop incursions across the border. By then, the town had three hundred residents, four general stores, a bank, a lumber company, a blacksmith, a drugstore and a newspaper, the *Lyford Gulf Current*.

The Roaring Twenties were a time of significant growth—by 1928 the community had a population of six hundred. Forty years later, in 1968, its population had doubled to 1,541. Those residents would soon find themselves protected by an unlikely apparition.

The Legend

Reports of phantoms haunting travelers are common across the globe. Folklorists have even given these tales a collective name: the vanishing hitchhiker. Since the first serious study of the repeated motif was published

in the *California Folklore Quarterly* in 1942, thousands of variants of the legend have been recorded.

The local version relates that in the late 1960s, a young woman was driving back home to Sebastian in her Volkswagen Beetle after attending a Chicano protest rally and concert in Corpus Christi. It was horribly late, but she had promised her parents she would not stay the night away from home. They respected her activist hippie ways, and she intended to respect their feelings as best she could.

It had been a long day, however, and Highway 77 was lonely and very dark. As AM radio stations switched to lighter, more romantic fare, she began to drift off, starting awake several times as the VW rattled across the dividing line or onto the shoulder. Her heart pumping adrenaline like mad, she would keep her eyes open for another fifteen minutes or so, only to slowly succumb to exhaustion again.

Somehow, she made it through Raymondville and the growing town of Lyford. But then, on that stretch of road before Sebastian, she fell completely asleep. Her car drifted erratically.

A man and his wife, hurrying north from Harlingen in response to a family emergency, had the misfortune of traveling along the highway at that moment. The Beetle slammed into their Plymouth Valiant, sending it flipping off the road while rolling over to skid to a stop several hundred feet away.

Woozy and bleeding from a cut on her forehead but otherwise miraculously uninjured, the young woman managed to wriggle free of the wrecked VW. Getting unsteadily to her feet, she saw the mangled remains of the Valiant silhouetted against a smoldering engine fire.

Moving as quickly as she could, the woman limped toward the wreckage, determined to save anyone still alive.

Focused as she was, she did not see the headlights of the oncoming truck until it was too late.

Forty years later, Andrés Cortez was returning to Harlingen after competing in an extreme motocross competition. His cousins were transporting his souped-up dirt bike, but he had decided to head back on his street-legal Yamaha, so exhilarated was he from his multiple wins.

Andrés blew through Raymondville just after midnight. Wisps of white began to stream across the highway, and then a thick fog bank rolled in off the Laguna Madre, cutting visibility down to just a few yards.

Conditions were so bad, in fact, that he almost hit the woman who suddenly loomed out of the mist.

The haunted overpass. *Alexis Tran.*

Braking hard, he slowed down and looped back, pulling up alongside her.
"Are you crazy, lady? You're gonna get yourself killed out here!"
She shook her long, braided hair. Andrés noticed how pretty she was, lit up by his headlight. She wore tight jeans that flared at the shins, along with hippy-looking sandals and a dark blue blouse. Totally not the right outfit for walking down the expressway like this.
"Sorry," she said, sheepishly. "I'm just trying to get home."
"Where do you live?"
"In Sebastian. Just beyond the overpass. But I'm scared of walking over it in this fog. You're right. It's dangerous."
Andrés reached behind him and unhooked his extra helmet.
"Let me give you a ride. Put this on. There's an earpiece so we can talk. Just guide the way, and I'll take care of you."
The woman reached out and took the helmet from his hands.
"OK. What's your name?"
"Andy. Andy Cortez. And you?"
She hesitated a moment, as if trying to remember.
"Susana Torres," she finally said with a smile, slipping the helmet over her braid and climbing onto the motorcycle behind him.

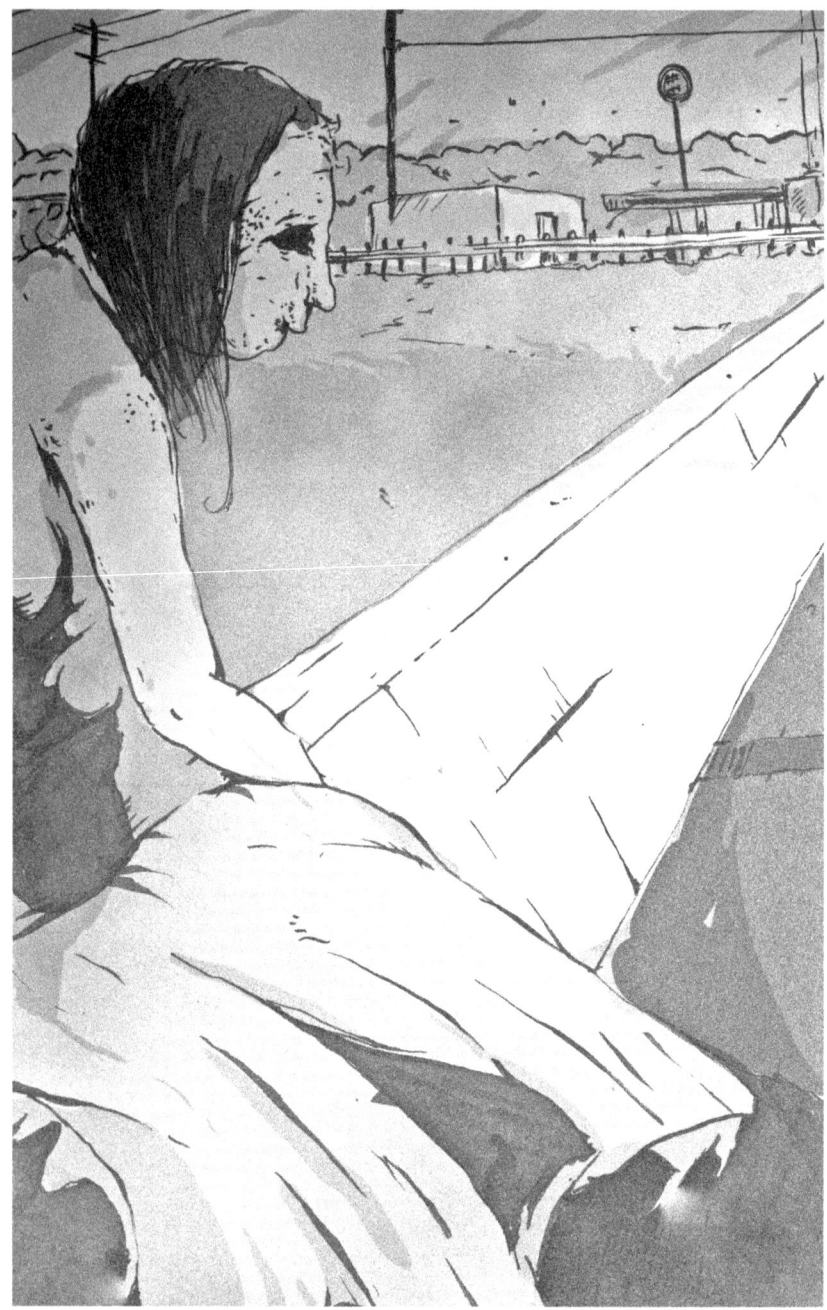

The lonely ghost of Lyford upon an overpass. *José Meléndez*.

"Nice to meet you," Andy said, trying out the Bluetooth connection.

"Likewise. Glad we bumped into each other." Her voice echoed strangely in his ear, as if the communication system was glitching or something.

"Yeah, me, too. Here we go. Hang on tight."

She wrapped her arms around him, and they were off. It was a nice feeling, having a pretty girl on the bike behind him. He felt a smile creep across his face, and he twisted the throttle a little more to give her a bit of a thrill.

"Careful," she muttered. "Take it slow."

Andy laughed despite himself, hoping the innuendo he heard was not just his imagination.

Gravity pulled at the motorcycle as the highway began to rise. They had just crested the overpass when a rattling semitruck burst through the fog, doing at least eighty miles per hour. The whole world seemed to slow as the streaming blast of air in the rig's wake slammed into the bike, wrenching the steering fork so hard that Andy lost control.

As the motorcycle spun around, spiraling toward the guard rail, Susana's arms suddenly plunged through Andy's chest, seizing his hands and clamping them onto the grips of the handlebars. Her fingers were ice-cold and impossibly strong.

He opened his mouth to scream.

"Relax," came her voice, soft in his ear. "No one dies on my mile anymore."

And with expertise that would put champions to shame, Susana Torres pulled the bike out of its spin, pointing it at the exit and braking as they hit the ramp.

Frightened, Andy downshifted with his left foot and applied the rear brake with his right. As they merged onto the frontage road, the hands protruding from his chest suddenly vanished.

He felt two short raps on his helmet as he came to a complete stop.

The pressure of her body was gone. Panicked, Andy let down the kickstand and jumped off his bike. Susana was not there. He peered off into the soupy air, but saw no sign of her.

His extra helmet was back in its accustomed place.

Examining it carefully, his heartbeat pounding in his ears, Andy discovered that the earpiece had melted down into a sludge of useless plastic.

Whatever force had saved his life, modern machines were clearly no match for her. Nor was death or that dark remorse that binds sad spirits to the place of their death.

No. She is ever watchful, eternally ready. If you happen along her stretch of road, she will be sure to keep you safe.

8
WILLACY COUNTY COURTHOUSE

THE HISTORY

Raymondville, the county seat of Willacy County, is popularly known as the "Gateway to the Valley," situated as it is at the very entrance to the Rio Grande Valley where Highways 77, 448 and 186 intersect.

Like most of Willacy County, Raymondville was originally part of the Agostadero de San Juan de Carricitos land grant, later acquired by Richard King and Mifflin Kenedy, who folded it into the vast King Ranch. In 1904, Edward Burleson Raymond, a foreman of the El Sauz portion of the ranch and owner of the smaller Las Majadas Ranch, organized the Raymond Town and Improvement Company to establish a community on land he had purchased from the King estate.

Raymond's company, along with the Kleberg Town and Improvement Company, made arrangements for the St. Louis, Brownsville and Mexico Railway to pass through the property in exchange for cheap fare for those considering investing in the new town. Raymond and Henrietta King sold lots to those who wanted in on the ground floor of Raymondville, as the town was soon called.

By 1914, a total of 350 people lived in the community. There were four general stores, a bank, a newspaper, a hotel, a cotton gin and a lumber company. The town's economic and physical growth depended on farming in those early days, with sorghum, cotton, citrus fruits, vegetables and corn being the staple crops.

The Willacy County Courthouse. *Alexis Tran.*

Raymondville was originally part of Cameron County. When lines were redrawn in 1921 in order to organize Kenedy County, Willacy's old center of Sarita shifted into the new county. Raymondville then became Willacy's new county seat. There was an urgent need for a courthouse, and architect Henry T. Phelps was hired to design an august building in the Classical Revival style.

Now a center of commerce and government, Raymondville grew by leaps and bounds. By 1929, it had a population of 1,800 souls. To this day, it remains a vital part of the Valley's economic health.

Yet that old courthouse seems to grow stranger as the town grows more vibrant.

THE LEGEND

When Anabel Real took a job as an office clerk in the Willacy County Judge's office, she was well aware of the stories. A longtime resident of Raymondville, she had grown up hearing about the ghosts that supposedly roamed the corridors and crannies of the nearly century-old building. But

she was skeptical of such reports, figuring them for the mindless wagging of unoccupied tongues. She had no time for such nonsense.

Intent on impressing her boss, Anabel found herself staying later and later, finishing up reports and maximizing the efficiency of the office filing system. Mrs. Herrera, the second-floor custodian, would shake her head every time she came upon the young woman, surrounded by piles of papers and manila folders.

"You should get out of here, m'ija," she often said. "Find yourself a handsome man and enjoy yourself. You're alive, child. Don't hang around here like the dead."

Anabel smiled at the unsolicited advice and thanked Mrs. Herrera for the sweets she sometimes brought her. But she kept working strange hours, driven by her inherent perfectionism.

One grueling night she rubbed her eyes and looked at her phone, only to discover that it was after midnight. Yawning, she stacked the remaining files on her desk and grabbed her purse to leave.

Faintly, from above, came a harsh jangling, like the sound of chains rattling in the distance.

Anabel froze, straining to hear.

There was a rasping next, as if a chair were being dragged across a rough-hewn floor. Then creaking, as of wind in the eaves or weight straining against wooden beams.

The young woman was so focused on the soft sounds that she jumped with a squeal of fright when the bang came, the sound a door makes upon being slammed open, hinges squeaking as it then swings back and forth.

"It's just the air conditioning," she muttered aloud, trying to calm her fluttering heart. "They said it's really old and worn-out. Or maybe it's just, I don't know, rats. Opossums. Chachalacas. Something rational. Don't be silly, Anabel. Just go home."

Despite her intellectual bravado, Anabel could not get the strange noises out of her mind all the following day. When night found her still trying to just accomplish her designated workload, she found herself hoping that Mrs. Herrera would pop her head in like always.

Around 8:00 p.m., her wish was granted. The elder woman had brought raisin tamales for her, and Anabel took a deep breath before launching into a description of what had transpired the previous night.

"Ah, yes," Mrs. Herrera said. "Even though there is a grand jury room up there, with people going in and out and so forth, the third floor of this building is haunted still. The basement, too—that's where they sent all the

tough cases, a sort of box with a big iron door to keep them in. But those boys lived long enough to get shipped off to the state penitentiary. Others weren't so lucky, Ms. Real. In the 1920s and '30s, everybody knew the rumors. That's why some prisoners refused to go up to the third floor on their own. You could get them onto the second floor courtroom without much fuss, but then they had to be pulled or pushed up an iron spiral staircase to the jail at the top."

"Why were they so stubborn? What made them afraid?"

"You ever been up there?"

"Just briefly, on the orientation tour. They showed us highlights."

"Well, that old jail has a gallows built in. Very strange affair with a large metal ring on the ceiling. They'd throw a hangman's noose through it, tie it off."

Anabel blanched. "Wait. You mean they hanged prisoners here? But that's . . ."

"Illegal? Maybe. Don't know what they teach in school these days, but the Rinches—the Texas Rangers, *malditos sean*—they started lynching Mexican Americans back during the Bandit Wars. You know, around the time of the *revolución*. Any excuse, they grabbed up people as supposedly rebels and whatnot. Local lawmen got involved, too. Even after the government made the Rinches stop, the hangings kept on happening, well into the 1920s, off the book. Authorities here in Willacy County did it right in front of other prisoners in their cells. Hanged those poor bastards from the metal ring. Hell, *no te asustes*, but the trapdoor for the gallows dropped down into what's now the women's restroom down the hall. Keep expecting one of the ghosts to come dancing down at me one of these nights when I'm mopping in there."

For a moment, Anabel sat in silence while Mrs. Herrera leaned on her mop, regarding her. Then the younger woman shook her head. "No. I mean, it's fascinating history, of course. But I don't believe in ghosts. There's a rational explanation for all of this, I'm sure."

"OK. *Como quieras*. Just watch out for yourself, is all I'm saying. And quit staying so late. They don't pay you extra for it, right?"

"No."

"Pos, there you go. Anyhow, I need to get back to work. See you tomorrow."

Anabel stayed for another half hour before shutting down her computer and flicking off the lights to the office. As she stepped into the hall, she could hear Mrs. Herrera singing some cumbia off-key in another part of the building. A smile played across her face as she shook her head. The custodian was something else, all right.

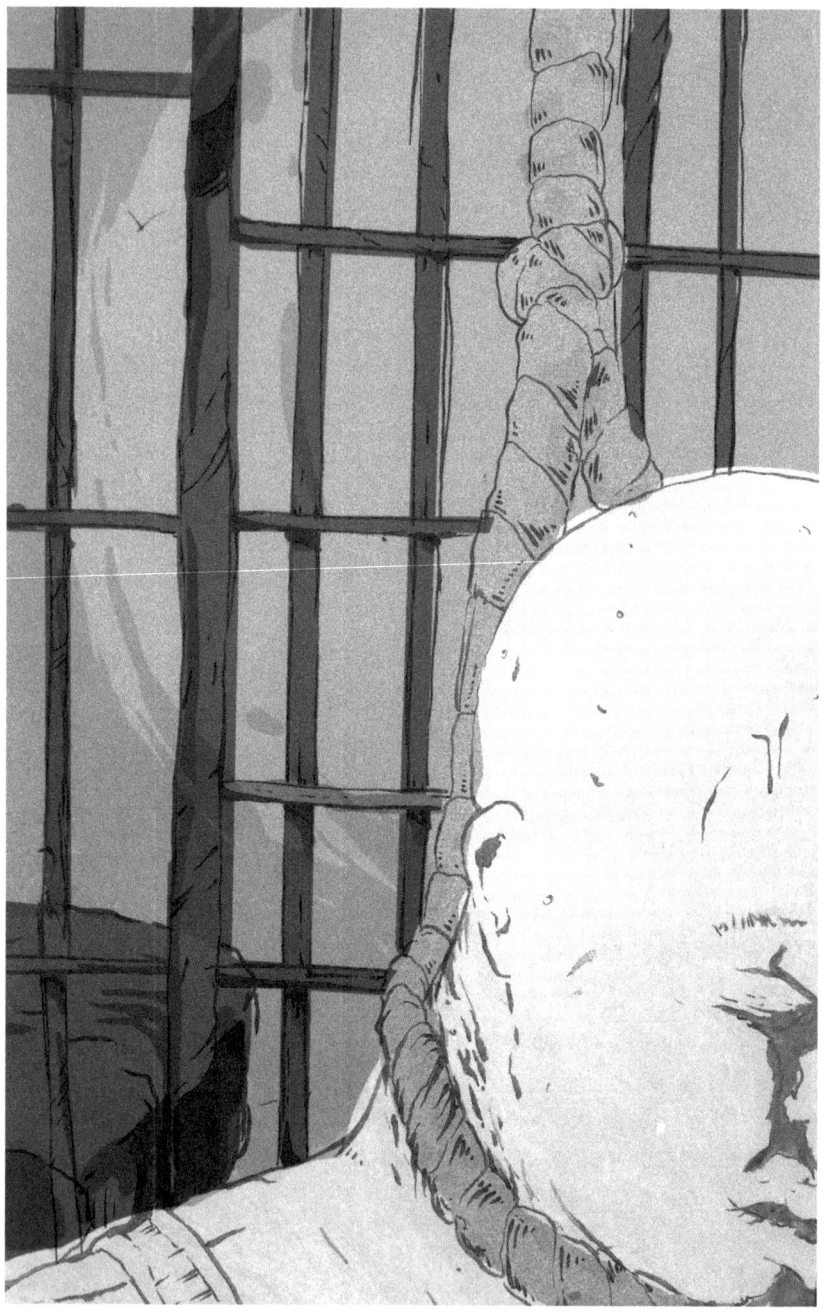

A hanged ghost that haunts the courthouse. *José Meléndez.*

Suddenly, a cold draft spun around her, followed by the jangle of shackles. At the end of the hall, a shadow eased itself out of the darkness of an empty doorway, lurching along one wall.

There was nothing there to cast the shadow, but it advanced with groaning steps all the same. About the size and shape of a man, the silhouette hung its head awkwardly as it came. Trailing faintly from the specter's neck was a length of rope.

A hangman's noose.

Throwing skepticism and false courage to the wind, Anabel ran headlong down the corridor to the stairwell, fairly leaping down the flight of stairs and past the night watchman, her eyes wide with terror.

It was the last time she ever worked late at the Willacy County Courthouse.

Hidalgo County

9
THE REVENANTS OF LLANO GRANDE

THE HISTORY

Many towns in southern Hidalgo County—Mercedes, Weslaco, Donna, Progreso, Edcouch, Elsa—were once part of the Llano Grande land grant under the Spanish crown. Juan José Hinojosa de Ballí, chief justice of Reynosa, Tamaulipas, petitioned King Charles III for the land in 1776, but the vast holdings were not officially granted to his heirs until 1790, a dozen years after his death.

One of the most vital biotic communities within the grant's confines was what is now called the Mid Rio Grande Delta Thorn Forest, home to hundreds of unique species of flora and fauna nourished by the broad but shallow Llano Grande Lake and smaller bodies of water created from its outflow, most significantly Tampacuas Lake, named for an indigenous tribe the Spanish encountered in the 1700s.

Two centuries after Llano Grande came into existence, the Estero Llano Grande State Park was established by cobbling together old farmland, trailer parks, nature trails and summer camps, adding them to existing parcels leased out by the U.S. Fish and Wildlife Service. The full reclamation of the wetlands is ongoing, of course, but the park held its grand opening in June 2006, offering the public over two hundred acres to explore.

A few people claim, however, that something sinister lurks at the heart of this paradise.

A haunted path in the Estero Llano Grande State Park. *Alexis Tran.*

THE LEGEND

Long before Spain claimed the territory along the Rio Grande, these lands were home to various indigenous groups known collectively as Coahuiltecans. One particular tribe thrived in the heart of the dense subtropical forest of ebony, brasil and wild olive that bordered the broad lakes of what is now southern Hidalgo County. There they were born, loved and died, their lives brightened by the call of the green jay and chachalaca, sobered by the ragged growls of jaguarundis, ocelots and pumas.

The Comecrudo tribe called these brush-dwellers Tompakawai—the tattooed people. When Spanish settlers arrived in the early eighteenth century, their European tongues transformed the name, and the native inhabitants of the Valley became Tampacuas.

Little more is known about them. Catholicism wended its way through the area, converting many, alienating others. The forest that had been so sacred to them and the river that fed their lakes and gave them sustenance were gradually usurped by ranchers armed with grants from the Spanish king that artificially carved up the lands on which they had freely ranged for centuries. Chief among these was Llano Grande.

The decades passed. New Spain became Mexico. Nuevo Santander became Coahuila y Tejas, then the Republic of Texas and, finally, the state of Texas.

Pushed to desperation by hunger, humiliation and homelessness, the Tampacuas raided Anglo American ranches in Hidalgo County from 1853 to 1855 until the U.S. Army entered the fray and relocated the dwindling population across the river, near Reynosa.

Fewer than one hundred had survived the ravages of colonialism and Manifest Destiny.

The Tampacuas were not the only indigenous group driven to such extremes in Texas. The once-mighty Karankawa—whose extermination had been pursued ruthlessly by Stephen F. Austin—found themselves hiding along the now-abandoned Tampacuas Lake.

Then a group of men from Mexican ranches crossed the river and finished the job Anglo-Americans had begun, snuffing out one of the oldest cultures in South Texas.

A year later, businessman Juan Nepomuceno "Cheno" Cortina—a champion of the rights of Mexican Americans in the Rio Grande Valley who despised the actions of the Anglo ruling class—took over Brownsville with a contingent of rebels after abuses by local law enforcement. After several conflicts, Cortina found himself retreating up the river, pursued by Texas Rangers under the command of Colonel John Salmon "Rip" Ford.

In December 1859, many Mexican nationals crossed the border to aid their tejano brethren. And with them, surprisingly, came the last of the Tampacua people, ready to avenge themselves on the Anglo armed forces and reclaim their ancestral lands and burial grounds along Llano Grande and Tampacuas Lakes.

They made a final stand there, struggling against all odds.

Every last Tampacua man was slain. But before they died, they felled dozens of Rangers there amid the nettles and brambles.

The effect of such slaughter was to compound the desecration of nearby burial grounds and overturn the spiritual balance of the thorn forest. Now, as darkness thickens in the undergrowth each evening, the restless dead return to haunt the thickets.

Since 2005, Estero Llano Grande State Park has held a Spooky Science Fest around Halloween each year. Johnny Reyna, an elementary student in Weslaco ISD, bugged his parents constantly after hearing about the event from his teacher. He loved science and nature and desperately wanted to go. If it meant giving up trick-or-treating, he did not care.

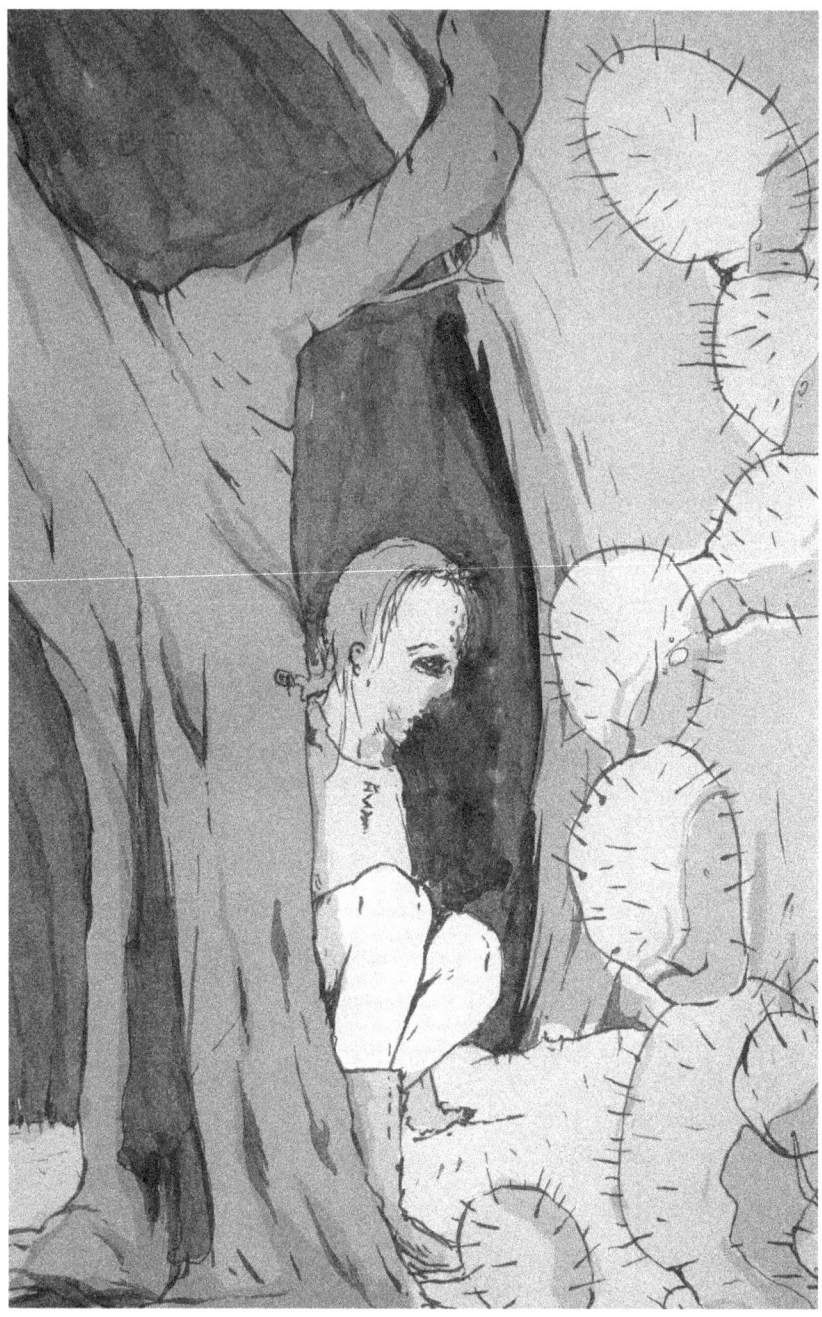

A ghost waiting in the Estero Llano Grande State Park. *José Meléndez*.

His parents could hardly say no to such enthusiasm. The family showed up at 6:00 p.m. on the appointed day and dove into the many activities—crafts, science experiments, a costume contest. Night began to fall, and children were regaled with spooky stories while adults and teenagers opted for night hikes through the wetland habitat.

Even though his parents would have preferred to stay in the lighted areas, Johnny was unrelenting in his desire to go on one of the hikes. The family followed their guide as part of a larger group, oohing and ahhing at the sights.

As Mr. and Mrs. Reyna paid careful attention to the historical yarns being spun, their young son saw a narrow path branching off from the main trail. On a whim, he ducked beneath an overhanging branch and began to explore.

It was hard to see, even with a nearly full moon above, but Johnny saw that a short distance ahead, the path became a sort of dark tunnel that bored its way into the brush. He stopped, entirely too frightened to even draw close, and started to turn back before his parents got worried.

Then, out of the corner of his eye, he caught sight of something. Twisting his head, he saw a face peering from behind a tree.

"Hello?" Johnny called. "Who are you? Did you get lost?"

A pale hand emerged, seizing the trunk of the tree. A strange figure pulled itself into the light of the moon.

It was a soldier of some kind, wearing an old-fashioned uniform.

Johnny hesitated, thinking this might be a Halloween costume. But then, from the tunnel beyond, other forms began to emerge, shirtless and glowing, long hair black as night, knives in their hands.

"Indians," Johnny whispered before a gasp rose in his throat. For he realized that he could see right through them. The soldier, too.

They were ghosts, all of them. The soldier raised his rifle. The Indians rushed him, silent as the stars.

Johnny did not wait to see what happened next. Loosing a horrified shriek, he dashed back along the path, screaming for his parents.

10

OLD HIDALGO COUNTY JAIL

THE HISTORY

The territory that has become Hidalgo County once comprised some nineteen grants issued by the Spanish and then Mexican governments that controlled the area, most notably the Llano Grande and Santa Anita tracts. As decades progressed and land was doled out in smaller and smaller parcels, large ranches broke up into smaller villages like Relámpago, Peñitas and La Habitación. The last of those, once known as Rancho San Luis, came into existence in 1774 just north of the river, where modern Hidalgo sits.

After Texas became a state, its internal divisions were reorganized. In 1852, Hidalgo County (named after the priest who was a hero of Mexico's war for independence) became the umbrella entity for some forty-five ranches and communities. La Habitación was made county seat under its new name: Edinburgh.

Edinburgh was situated right on the floodplain of the Rio Grande, however, and after the town flooded and moved a couple of times, government officials knew something had to be done. Texas law further required that county seats be located near the geographical center of a county.

The choice was made in 1911 to make the freshly established city of Chapin the new county seat. There was a slight wrinkle—its namesake and founder Dennis Chapin had been involved in a shooting in San Antonio. County officials struck on an interesting plan. Changing the name of

The old Hidalgo County Jail. *Alexis Tran.*

Edinburgh to Hidalgo, they then renamed Chapin Edinburg (dropping the H to differentiate between the new town and the old).

With the county seat established and the nomenclature sorted, the leadership of Hidalgo County contracted popular architects John Phelps and Atlee Ayers to design both a courthouse and a jail. Examples of the Spanish Mission Revival style, the two buildings went up on the Edinburg square in 1910. The brick and concrete jail was as solid as could be, with cells on the second floor squat and impregnable beside the hanging room that had been built within the tower.

Though it stood as a sobering warning to criminals throughout the county, that high gallows was only used once in the jail's decades-long history. The state took over the task of executing men and women in the newfangled electric chair soon afterward.

Even that one death was enough to leave a mark. The people of Hidalgo County hanged a monster that day, and his sordid soul has haunted the place for more than a century.

The Legend

In February 1912, Martín Martínez and his wife, Florencia, residents of the border town of Hidalgo, had just returned by ferry after running a few errands in Reynosa on the south bank of the river. As they walked beside the city cemetery, heading for their modest home, two young men leapt out from behind the tombstones, snarling like beasts or demons. One smashed a solid length of wood against Martín's temple, tumbling the man dead in the dust before kneeling to rummage through his pockets and packages. The other seized Florencia and began to drag her toward a tumbledown shack not far from the graves.

The next twenty-four hours were a hellish ordeal. The men took turns raping and tormenting Florencia, laughingly discussing their plans to kill her when they had used her up. As they drank rotgut tequila and blasphemed against everything holy, Florencia studied their features in vengeful silence.

When they finally passed out, she made her escape, running through the cold winter's morning until she reached the heart of the city and told law enforcement what had happened to her. Deputy William Brewster put together a posse, and they scoured the area near the cemetery. A hunch led them to talk to W.L. Lipscomb, foreman of the nearby San Juan Plantation. Two of his laborers had indeed shown up late that day, stinking of liquor.

When the lawmen fell upon them there in the fields, the older man, Domingo González, managed to escape, eventually fleeing to Mexico. But twenty-one-year-old Abram Ortiz found himself under arrest. Deputy Brewster demanded he show them where he had left the body of Martín Martínez. Ortiz took them to the exact spot, his expression remorseless. His guilt appeared certain. He was transported to Edinburg and thrown into the county jail.

"That's him!" Florencia exclaimed, trembling with hurt and rage, when she was brought in to identify Ortiz. "He killed my husband. He raped me along with the other one."

These were capital offenses. A grand jury handed down indictments on both counts. Out of a pool of both Anglo and MexicanAmerican jurors, twelve Anglos were selected for the jury, and a court date in April was set. González would be tried in absentia along with Ortiz.

The presumed killer spent those initial months in one of the three cells of the jail's death row. When the trial began, he was moved to the maximum security cubicle, awaiting his fate behind a thick steel door.

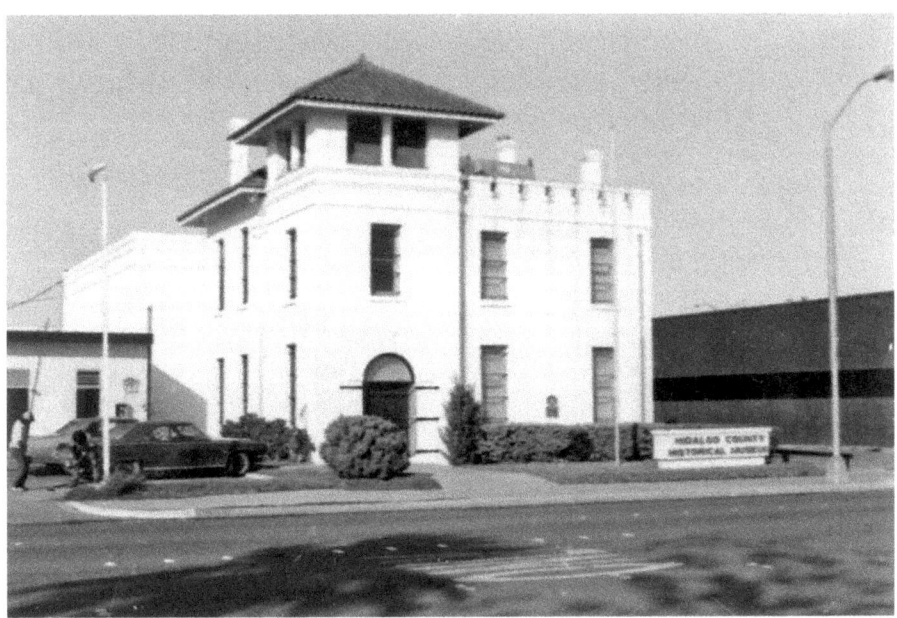

The Hidalgo County Jail in the mid-twentieth century. *University of North Texas Libraries.*

Florencia Martínez was the prosecution's key witness. Her testimony was harrowing and—according to the defense—inflammatory. The jurors were visibly affected by the gruesome details, and the community began to cry for blood. After the testimony and arguments, the jury took little time in returning a guilty verdict.

Ortiz was sentenced to death by hanging in the tower gallows.

The head jailer, Enemecio Cortina, had the convict moved to an open cell for his last hours of life, posting a guard to keep Ortiz from trying to escape his punishment through suicide. The prisoner had refused to see a priest. It was a bad sign, Cortina knew. There was something deeply wrong with the prisoner.

From where he sat on his cot, Ortiz had a clear view of the door that led to the hanging room. As he stewed in whatever dark thoughts swirled within him, he had to listen to workers as they activated the trapdoor again and again, ensuring it worked properly. The clanging slap echoed for blocks all around, chilling the blood of Edinburg's residents.

The morning of May 2, 1913, people began to arrive from all over the Rio Grande Valley to witness the hanging—on foot, on horseback, in wagons or cars or trains. Hundreds of spectators had lined the square by 10:30 a.m.

Twenty minutes later, jail officials guided Abram Ortiz to the hanging room. Wearing black pants and a light brown shirt, he shuffled along slowly, the shackles on his legs making a dreadful jangling sound until he came to a stop on the cool steel of the trapdoor. Looking out the south window of the tower, Ortiz could make out the crowd, swelling larger and larger by the minute.

Enemecio Cortina began to drape a black hood over his head.

"No." It was the first word Ortiz had said in weeks.

"You have to wear it, son."

"No. I want to look you in the eyes. All of you."

Cortina frowned. "Trust me, son. You don't want us staring at your face. We don't want to, neither."

Ortiz spat. "That's 'cause you're weak. I ain't afraid of death, but you all are."

"No, you don't understand. Your eyes are going to bulge out. Your tongue is going to swell. You really want people seeing you like that? You, the powerful and immoral Abram Ortiz?"

The condemned man hesitated. Then he relented.

"All right, damn it. Go ahead and put the thing on me."

Cortina drew the hood over his face and slipped the noose around his neck. "Any last words?"

A low chuckle came from beneath the black fabric, muffled but sinister.

"Yeah. No goodbyes and no regrets. I'm going to cling to this world like a tick, you sons of bitches. Know why?"

Ortiz tilted back his head, drawing a deep breath, and screamed as loud as he could: "There is no heaven and no hell!"

It was 11:00 a.m. A train whistle sounded in the distance. The hangman, shaking his head in disgust, yanked on the steel lever, releasing the trapdoor with a clang that reverberated across the square. Ortiz kicked at the air just ten inches from the floor, twisting and twitching his life away.

After the coroner pronounced him dead, the corpse of Abram Ortiz was unceremoniously dumped into a wooden coffin and carried out of the jail.

No one claimed his body.

As there was no municipal graveyard in Edinburg yet, rancher Patricio González, who owned a store in town, offered to allow the city to temporarily bury Ortiz on his property, at the edge of his family cemetery. There, beneath a mesquite tree, two teenaged boys dug a grave and helped ease the coffin into the earth.

No prayers were intoned. No one marked the grave. The city never relocated the corpse. In time, its resting place was forgotten by all—except

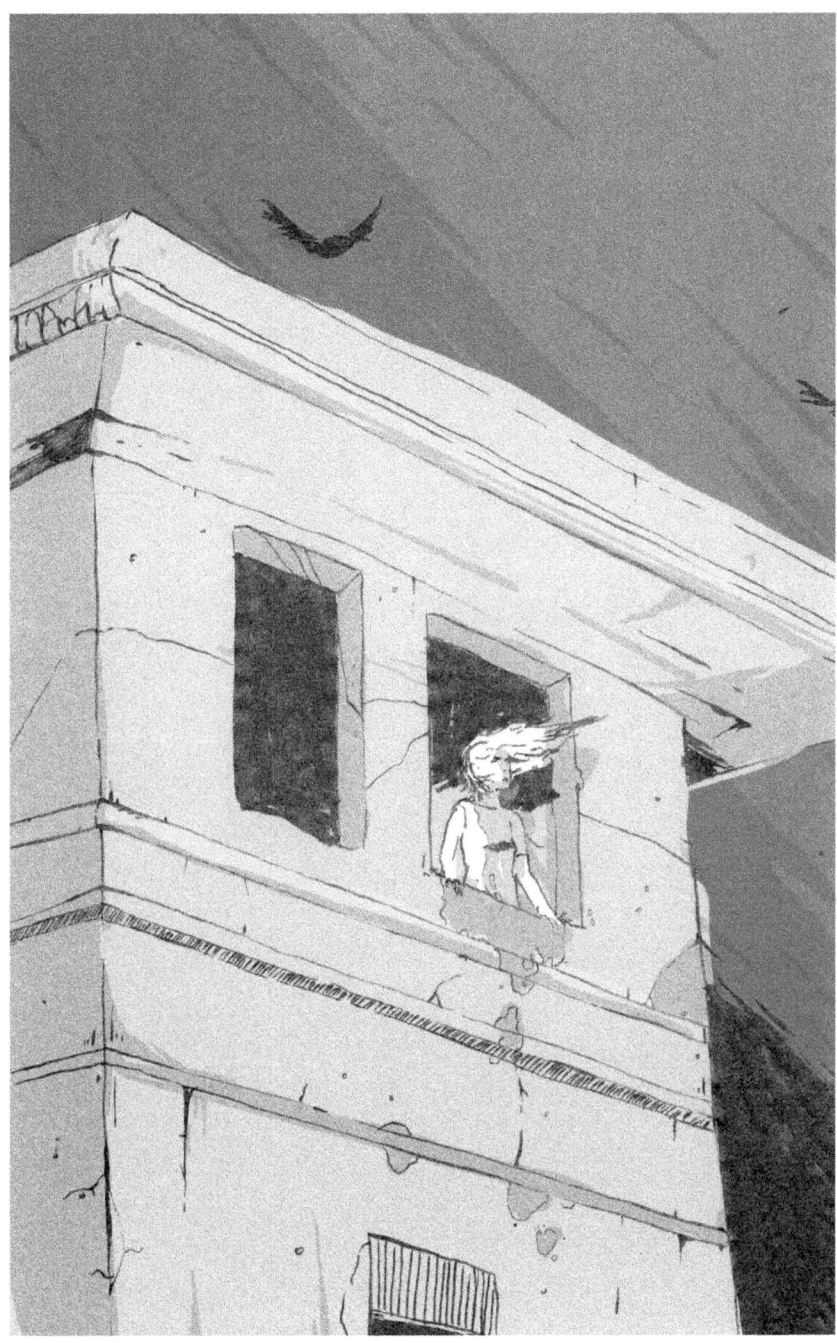

The ghost of Abram Ortiz. *José Meléndez.*

Abram Ortiz himself, the legend goes. True to his dying word, the killer and rapist has clung to the world, drawn back to the lonely cell and hanging room where he spent his final days.

That jail still exists, now part of the Museum of South Texas History. If you ever visit, you will find the maximum security cubicle with its steel door. You can stand in the death-watch cell and contemplate the dark thoughts and inscrutable feelings of a monster on the verge of execution.

And then maybe, if you listen very closely, you will hear the sound of his shackles rattling. The room will grow cold. An oppressive clenching will seize your chest.

Then, just faintly louder than your own fluttering heart, you will hear that muffled chuckle, gleeful and cruel.

11
THE WRAITHS OF THE SAN JUAN HOTEL

Imposing even as it slowly crumbles, the San Juan Hotel stands enigmatically at the heart of Hidalgo County. The local folks swear they have heard eldritch screams and desperate cries for help drifting from its moldy guts. More than one person has seen a frantic woman at a second-story window at night, waving frenziedly.

How did the hotel come to be haunted? In order to grasp the origin of its poltergeists, we need first to fully appreciate the origins of the building itself and the city that gave it birth.

THE HISTORY

Clustered together along Highway 83 are three towns that emerged together in the first decade of the twentieth century, founded on lands purchased cheaply from aristocratic families. Over time, they have gradually come to be thought of as a single metropolitan entity, the tri-city zone known as PSJA: Pharr, San Juan and Alamo.

All three ventures came to fruition in the year 1909. John Connally Kelley Sr. and Henry N. Pharr became co-owners of a sixteen-thousand-acre tract that fronted the river. Pharr used his Louisiana and Rio Grande Canal Company to build a complex irrigation system for a sugar plantation he intended to establish. Hoping to forge a community around his partner's

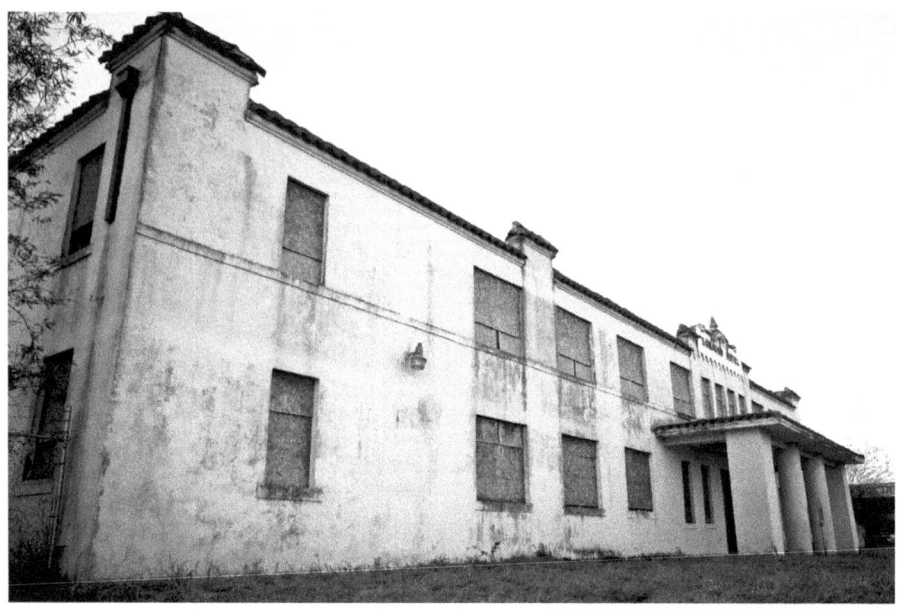

East view of the San Juan Hotel. *Alexis Tran.*

agricultural empire, Kelley set up the Pharr Townsite Company. Though the sugarcane industry collapsed, deflating Pharr's dream, the town named in his honor flourished. By the breakout of the "Bandit Wars" in 1915, some six hundred souls lived in the community, and separate grammar schools opened for Anglo and Mexican American children. No junior or senior high schools were built for the Spanish-surnamed teenagers, however, as it was expected they would begin to work after sixth grade at the latest.

John Closner—a former sheriff and deputy marshal who had scraped, climbed and reputedly cheated his way to the top of the Anglo landowner class—organized the community of San Juan in 1909 as well. Though the town superficially bore the sainted title of John the Beloved Disciple, Closner in fact named it for himself in a tongue-in-cheek play on Spanish Catholic sites, much as was done at San Benito and San Perlita. After classes had been taught in residents' homes for nearly a decade, a school building was finally erected. In 1919, the Pharr-San Juan-Alamo Independent School District was established, making the unity of the three towns official in the sphere of education.

A few miles east of San Juan, Peter Ebenezer Blalock and George T. Hawkins had acquired thirty-two thousand acres of land by 1908. Close to the railway, the two men laid out a town and constructed a depot. For a

time, the community that began to grow up around the shipping pens was called Camp Ebenezer. Blalock and Hawkins sold the land to the Alamo Land and Sugar Company, whose owners C.H. Swallow and Rentfro B. Creager moved the town to higher ground and named it first Forum and then Swallow. Neither moniker stuck, so when the men organized a company to seek official incorporation, they christened it the Alamo Townsite Company, after the mission in San Antonio.

Not long after its founding, this tri-city zone came to be dominated by a man whose name inspires awe or hatred to this date, depending on whom you ask—Thomas Shannon "Tom" Mayfield, also known as "Whispering Tom."

Born and raised on a farm in Gonzales County, Tom Mayfield left those rural surroundings in 1898 to trade horses for Teddy Roosevelt's Rough Riders. After that, the prospect of working the railways brought Mayfield to the Rio Grande Valley, where he met and married schoolteacher Moody Denley Edwards and began working with John Closner, first on his sugarcane plantation and then as part of his security detail.

At the time, Closner was the sheriff of Hidalgo County, and he tapped Mayfield as a deputy. When the county seat moved to Chapin from Edinburgh in 1908 (a move opposed virulently in some circles), Tom was one of the armed men who escorted the mule-drawn wagons that transported county records to ensure their safe delivery.

In 1914, Closner ran for treasurer instead of sheriff, and Mayfield soon had a new boss—former Texas Ranger Anderson Yancey Baker, who had a reputation for heartless cruelty, shooting Mexican Americans dead in cold blood. This brutality was exemplified by his killing and mutilation of Ramón de la Cerda, owner of a small ranch adjoining King Ranch. Baker had been acquitted after considerable capital and legal investment by the ranching empire, but many in the Mexican American community along the river hated and feared him.

These two men would be key in sparking what has been called the Bandit Wars. In January 1915, Baker received a tip from former Starr County sheriff Deodoro Guerra that a Mexican national named Basilio Ramos had approached McAllen physician Andrés Villarreal, trying to recruit him into a revolutionary movement guided by a document known as the *Plan de San Diego*, which advocated the hostile retaking of the American Southwest.

Tom Mayfield was sent to arrest Ramos; he found a copy of the document on him, and panic struck the heart of the landowning class in the Valley. Texas Rangers and troops from several state militias were dispatched

to the area. They clamped down viciously on the Mexican American community. Hundreds disappeared or were outright killed, often on the slightest suspicion of collusion with rebels, and unconstitutional justice was summarily dispensed via bullet or noose. There were, of course, incursions and guerrilla attacks by actual revolutionaries that resulted in a score of American deaths, but the common people bore the brunt of lawmen's retaliation.

Chief among those violating rights in a fervid desire to keep Mexican Americans in their place was Tom Mayfield. John Peavey, a deputy in neighboring Cameron County, recalled in later years that Mayfield was an animal of a man who did not bother to jail the Mexican Americans he arrested, preferring to beat them to death with his pistol if he could.

Late in 1915, Tom Mayfield reported finding the dead bodies of fourteen Mexican American men near Alamo's city park. No investigation was made. Mayfield and several Texas Rangers buried the bodies and did not report their resting place.

Cosme Cásares Muñoz witnessed the massacre from a distance and told everyone who would listen that a posse of lawmen had hanged the men in trees on either side of the railroad track. Other residents who saw the bodies after they had been taken down said they had also been burned and shot through the head.

The deputy denied the charge leveled against him, that he himself had lynched the men with the help of rogue Rangers. In fact, he went to his grave refusing to reveal what testimony he had finally given to authorities, testimony that was suppressed and never published.

Right after this incident, Mayfield enlisted as a Texas Ranger for two years. When the armistice ended World War I, the violence subsided in the Valley as well. Life in the tri-city zone returned to relative normality.

With business booming, the need for lodging became acute. The San Juan Hotel was completed and opened for business in 1920, right at the heart of John Closner's town. San Juan's business leaders hoped to make of the town a center of commerce, and they continually tweaked the unornamented style of the original hotel, adding Mission Revival details similar to those seen on buildings across the Valley.

Mayfield, losing his commission as a deputy sheriff, had gone to work as a guard for the American Oil Company at their installation in Mexico. His penchant for abusing Mexicans did not go over well in that country, of course, and the former Ranger found himself before a firing squad in 1921. He managed to escape, only to have his throat cut in a cantina—the

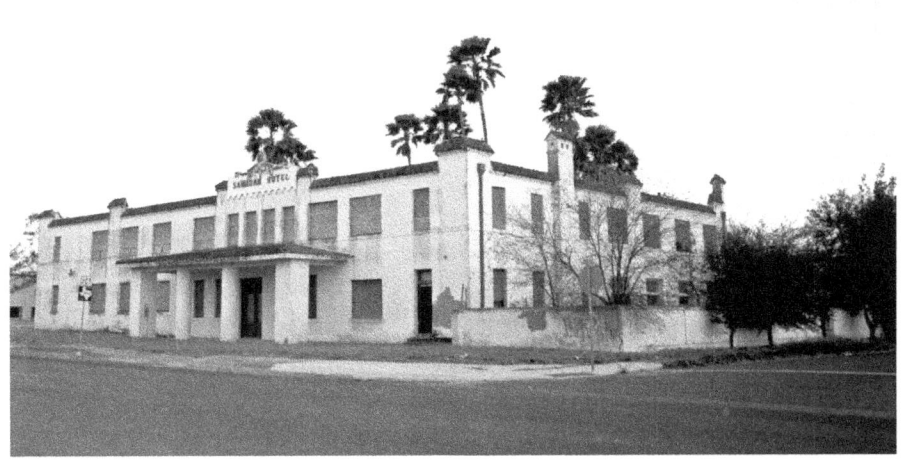

West view of the San Juan Hotel. *Alexis Tran.*

resulting damage to his trachea was what gave him his infamous nickname of Whispering Tom.

Over the years, many deaths occurred at the San Juan Hotel. Oral histories of Mexican American families in the community affirm that Mayfield, who returned to the United States and served as deputy constable for Pharr–San Juan–Alamo from 1938 to 1963, continued to brutalize Hispanics on the hotel grounds.

Strangely enough, having lost his wife to divorce and with a reputation as a monster among the Mexican American population of the town, Mayfield spent his last years as a resident of the now haunted San Juan Hotel, where it is said he died alone in 1966 at the age of eighty-six.

Was he truly alone at the moment of his death? Legend suggests otherwise.

The Legend

Many people came to visit Whispering Tom in his gloomy hotel room: reporters, students, collectors of historical objects and lore.

Allen Miller was different. He wanted to be the former lawman's apprentice.

"Apprentice?" the old man hoarsely asked. "The hell do you mean?"

"You knew how to deal with them," Miller explained. "The shiftless malcontents, the lesser breeds, the lower men who're ruining our country. Papists. Mongrels."

Tom Mayfield looked the stranger up and down. Tall and lean, Miller stared back at him with pale eyes that glittered with intelligence and malice.

"Well, I don't know about all that. I kept the peace. Punished the wrongdoers. Sent a message to would-be criminals. Did some folks object to my methods? Sure. But it was a frontier, the Valley was. Lawless place. Still is, in spots. Takes a firm hand to keep the mob under control."

Miller nodded avidly. "That's what I want to learn from you, sir. That firm hand."

The stranger was persistent, renting a room on the same floor and visiting Mayfield regularly. Gradually, the old man warmed to Miller, opening up and sharing the techniques he had used to strike fear into men and women at precisely the right moment, to punish without impunity those whom the liberal law might otherwise leave be.

Perhaps Whispering Tom should have realized he was talking to a sociopath. Perhaps he actually did. Whatever the case, after a month or so of these dark conversations, Allen Miller decided the time had come. The righteous calling squirmed in his breast, eager to burst into fruition.

He intended to kill a prostitute.

Life was tough for Ambarina Rivera. A year earlier, her husband, Raúl, had died in the far-off land of Vietnam, serving a country that did little to support the widow and her three children afterward. Desperate for money in very tough economic times, Ambarina had been lured by a cousin into the sex trade.

She was not proud of being a prostitute, but she was not ashamed, either. It was a matter of supply and demand, like all work. No dirtier than cleaning some gringa's house, she told herself. It paid better, too. Her children ate well, wore decent clothes and lived in a good home. She had no regrets.

"Take what you can from them," her mother had surprisingly said when she had finally learned the truth. "From every man you can, especially the gringos. They owe women a blood debt for what they've done to us, m'ija."

Ambarina did not feel the same hatred as her mother, but the advice was still good. Men had their uses, of course. Protection was one. She plied her trade in San Juan's red-light district, safe as a member of a stable run by Fernando Cuevas, one of the toughest criminals in the neighborhood. So she did not worry too much when the black Triumph

Saloon pulled up and the tall Anglo got out to approach her. He was polite and demure. She named the price, and he agreed.

"We can go around the corner to a room I rent close by," she said.

"I'm staying at the San Juan Hotel. Much nicer, wouldn't you say?"

"All right. Let me just let Fernando know."

Fernando urged Ambarina to squeeze her john for a little more cash. After they had negotiated the new price, she got in the sedan, and they drove the mile or so to the hotel.

His room on the second floor was spotless and nearly empty, as if he might pick up and leave at any moment. Ambarina had been hired by such men before—traveling salesmen and gamblers, unmoored fellows drifting at the edges of society.

"Let me see the money," she said softly as she unbuttoned her blouse. He showed her a fifty-dollar bill and turned to set it on the dresser with a sharp tap of his fingertips.

Ambarina smiled. "Good. Now just come over here and relax. We're going to have . . ."

Without warning, he swung around, his arm outstretched. Ambarina noticed the straight razor in his hand just as it bit into her flesh, slashing her throat open.

"Silence, you brown whore," he snarled at her. "Your sins have been judged; your heart has been weighed. Now lie down and die for me."

Ambarina collapsed. As her life drained out of her, all she could think of were her beautiful children, orphans now. Their little faces filled her vision as the world swirled blackly away.

When Ambarina did not return, Fernando Cuevas went looking for her at the hotel. The employees remembered that Mr. Miller had gone to his room with a woman matching her description. Then he had checked out, though no one remembered seeing his guest leave with him.

They found her in a pool of her own blood, lifeless on the bed.

After police had questioned him thoroughly about Allen Miller, Tom Mayfield stood in his doorway, watching men from the coroner's office carry her body out on a stretcher, covered by a sheet dotted with red stains. Even as brutal a heart as his could not help be moved just a little by such a senseless death. He had no problem with prostitutes who knew their place. He had availed himself of their services often over the years.

What a waste.

In the months that followed, Whispering Tom often thought of his apprentice, of the lessons he had learned. Thinking through such acts

The prostitute murdered in the San Juan Hotel. *José Meléndez*.

helped him bury them deep, where he had stifled his last vestiges of guilt years ago. Eventually, he was able to put Miller and the prostitute from his mind entirely.

Then the voices started to murmur in the walls around him. Indistinct at first, they slowly resolved themselves into accusing voices of his past, men and women whose lives he had taken or destroyed, some in that very town. They enumerated his crimes, even the most private and hidden offenses. Their whispering voices pried at his dark soul, unearthing his shame.

Tom's health deteriorated. Soon he was essentially confined to his room, visited by a nurse from time to time.

That is when she appeared, the prostitute, with a parade of ghastly wraiths in tow that passed writhing through his squalid quarters, looking at him with hollow, accusatory eyes. The procession loomed closer and closer with each passing day, holes gaping in their skulls, nooses flapping grotesquely around constricted necks, faces battered and broken by rifle butt and pistol grip, flesh curled and crisped by torch flame.

When at last his doctors confined him against his will to a room at the San Juan Hospital, the ghosts followed, drawn like flies to rotting flesh. They made the last few months of Mayfield's life a living hell. Pride kept him from complaining. He endured their harrowing presence with jaw clenched tight, unrepentant to the very end.

Folks say that when his soul finally fled his failing flesh, the wraiths were waiting to drag him away to his eternal reward deep in the rotting recesses of the San Juan Hotel.

12
MCALLEN'S CASA DE PALMAS HOTEL

THE HISTORY

The largest city in Hidalgo, center of commerce for the area and perhaps the most widely known Valley community in the outside world, McAllen came into existence as a sort of hostile merger between two different, competing communities in 1911.

Its namesake, John McAllen, could hardly have imagined this eventuality when he married Salomé Ballí de Young, the widow of his former boss, John Young, in 1861. Salomé held considerable property at the time. She had inherited most of it from her great-grandfather José Manuel Gómez, who had established the Santa Anita Ranch in 1797 on 95,000 acres granted him by King Charles IV of Spain. She and her late husband had since acquired and annexed surrounding property, and she continued this practice with her new spouse. They renamed the estate the McAllen Ranch. By 1885, it comprised 160,000 acres.

When the railroads finally reached the ranch in 1904, John McAllen and his son James Ballí McAllen donated land so that the tracks would pass through their property, which they had decided to transform into a town. They set up a company to explore possibilities along with James's older half brother John J. Young, Harlingen founder Lon C. Hill and Uriah Lott, president of the St. Louis, Brownsville and Mexico Railway.

The new town of McAllen grew slowly despite being the site of the train depot closest to Edinburg, the county seat. Its sickly infancy was complicated

by the establishment of a new community just two miles to the east, the work of John Closner, William Briggs and O.E.M. Jones, who arranged for an irrigation canal and used their business connections to quickly attract some three hundred souls to the town. People began to call the settlement East McAllen, and it siphoned businesses and residents away from "West" McAllen until the original community was a ghost town. The 1911 charter of incorporation renamed the second city simply "McAllen." It had, in effect, completely absorbed its rival sister.

As the city continued to burgeon madly, Mexican Americans found themselves increasingly segregated, despite the multiethnic background of some of the city's original founders. The McAllen Real Estate Board and Delta Development Company worked diligently to keep Mexican Americans on the south side of the tracks. Elementary schools were completely segregated, though no junior or high school facilities existed for students of Mexican heritage, as it was expected they would leave school by the end of sixth grade.

In fact, once McAllen Municipal Hospital opened in January 1925 and then expanded into the McAllen General Hospital two years later, doctors with Spanish surnames were not even allowed into the main hospital building, instead being relegated to a remote corner of the basement.

When the so-called Bandit Wars exploded in 1915–16, the state of New York sent twelve thousand National Guard soldiers to McAllen to help suppress the feared uprising of Mexican American rebels. The influx of men sent a jolt through the local economy, and by 1920, the city's population had ballooned to six thousand.

Appropriately enough for such a tumultuous and often-traumatic birth, McAllen is the site of several different hauntings. The new McAllen City Hall was built in 1995 on the same ground where the segregated McAllen General Hospital once stood. Now, as dark falls, municipal employees are faced with inexplicable occurrence. Drawers open and close by themselves. The sound of paper ruffling wafts from empty rooms. Strangers in old-fashioned garb wander the halls, question people they come across, and then enter a restroom on the second floor—only to evaporate without a trace.

Clearly, something has disturbed the eternal rest of former patients. But their haunting is relatively recent. For the oldest ghost-infected spot in town, one only has to drive a mile or so away, from Houston Avenue to the corner of Tenth and Main Street.

The Legend

As McAllen's economy boomed after the departure of the New York National Guard, it become clear the city needed a luxury hotel. A parcel of land across the street from Archer Park (named for the second mayor) was developed, and a sixty-room resort in the Spanish Colonial Revival style was erected in 1918. Named the Casa de Palmas Hotel, the twin-towered building sported red tile and twenty-four-inch-thick walls, enclosed by a palm-fronded outer patio. Every room face outward, allowing cool gulf breezes to delight the guests. With its beautiful salon and private dining rooms, the hotel soon became the center of business, social and civic events in Hidalgo County. Over the years, important public and private affairs were held at the Casa de Palmas, as when Fidel Castro, freshly bailed out of prison by Mexican president Lázaro Cárdenas, had a clandestine meeting with former Cuban president Carlos Prío Socarrás in January 1956 to solicit funds for his guerrilla troops.

Other happenings, while not nearly as notorious, have left a deep ethereal mark on the site. Odd sounds can be heard, and the telephones in the hotel ring unexpectedly, with no one on the other end. But the most spine-tingling strangeness is the appearance of ghostly figures in different areas of the hotel. An elderly lady has been sighted in the basement, wandering aimlessly as if search of something she's lost. Guests leaving their rooms in the middle of the night claim to have seen a veiled woman drifting somberly along the halls, her black garments suggesting mourning cut short by tragedy.

At least one of the poltergeists is known to the staff—the spirit of Miss Roxy, a former employee of the hotel who committed suicide years ago. She can be seen from time to time on the third floor, near where her office was once located, moving about purposefully with vim and verve the way she did when alive.

Normally, the owners or residents of haunted places can hardly turn to the authorities for help, at least not the local law enforcement agencies. But several decades ago, staff mistook an apparition for an actual flesh-and-blood human, and the resulting confusion has been recounted again and again down the years.

The hotel manager returned to Casa de Palmas late one night to finish up some paperwork he had left pending. As he exited his car, he chanced to look up at the moon, which floated majestically just above the north tower.

An unexpected figure was silhouetted in one of the archways—a woman with flowing hair, dressed in a white gown.

Hidalgo County

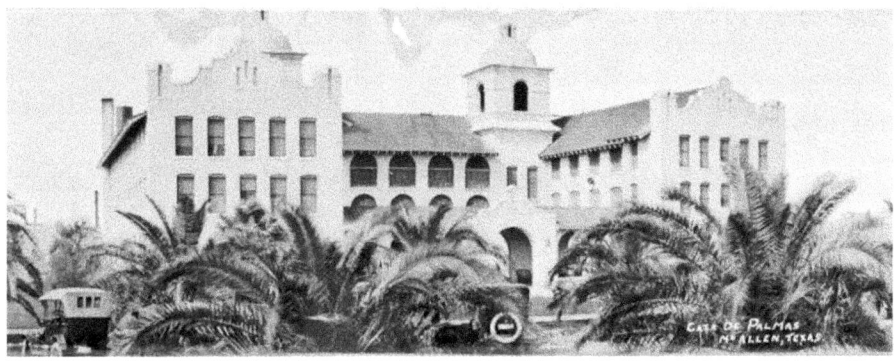

The Casa de Palmas Hotel shortly after its opening. *The University of Texas Rio Grande Valley.*

"You've got to be kidding me," the manager groaned. Hurrying inside, he confronted the concierge.

"There is another woman," he gasped, "in the tower! How did she get in there?"

"No idea, sir. Should be locked up tight. You and I are the only ones with keys."

"Well, damn it, go up and get her."

The young man swallowed heavily in annoyance and moved to comply. Before long, however, he came down alone.

"The door is wedged shut," he said with chagrin. "I keep calling for her to come out, but she won't answer."

The manager groaned and clutched his temples. "I'm not in the mood for this. Not again."

Smashing the buttons of the lobby phone with urgent fingers, he called the McAllen Police Department. A car was dispatched at once.

Two officers arrived about ten minutes later, a man in his twenties and his older female partner. The manager accompanied them to the stairwell that led up to the room atop the tower.

"Stay here, sir," the female officer indicated. "It's safer that way."

They climbed cautiously to the top and tried the door. The knob turned, but the door was jammed shut.

"Ma'am," called the older cop, "McAllen PD. We're going to need you to open up at once."

A faint rasping came from the other side, nothing more.

"Forget this," the officer muttered to her partner. "Come on, Gómez. Let's try to bust it down."

He nodded and cast his voice loudly. "You need to get away from the door, ma'am. We're coming in by force."

The cops looked at each other. Gómez counted down from three on his fingers. Then they slammed their shoulders against the door.

It swung open unexpectedly, throwing the two off balance as they went twisting into the room.

No one was there.

"What the hell, Jones?" Gómez muttered, reaching for the light switch. "Someone's messing with us."

The lights came up. The room was definitely empty.

"Let's go tell the manager he's been pranked," Jones said, shaking her head. "Either that or he's drinking on the job."

As they turned to leave, however, the door slammed shut. Gómez growled a curse and yanked on the knob. The door would not budge.

"Listen up, whoever's on the other side of this. You're about to be arrested. Things'll go better for you if you immediately open this door and let us through."

For the space of a few seconds, there was no response. Then the lights began to flicker and tremble as the temperature dropped.

Without warning, Gómez was lifted bodily into the air and flung against the wall between two arched windows. It was as if an invisible hand were thrusting against his chest, holding him in place.

"Jones . . .," he managed to gasp.

His partner was hurrying toward him when something yanked on her shoulder and spun her around. She reached for her sidearm, but the clasp popped open by itself and her pistol went flying through the air, smashing through a window and falling with shards of glass onto the palm trees below.

Gómez was released, and he crumpled to the floor, his chest heaving as he caught his breath.

"Oh my God, Jones!" he rasped frantically. "It's a freaking ghost! What do we do against a ghost?"

Looking at the window and then at her partner, she shrugged noncommittally. "They skipped this stuff at the academy."

Trying to stay calm for his benefit, Jones walked over to the window and peered out, looking for her weapon. Something caught her eye just below the sill. Strands of fine black hair, snagged on the stucco. She thought she could make out a bit of blood.

"But I've read a lot. Horror novels, that sort of thing. Why are places haunted, Gómez?"

The ghost at the Casa de Palmas Hotel. *José Meléndez*.

Getting to his feet, her partner shrugged, wobbling a bit. "Beats me. Because people die there?"

"Yeah. And they leave a trace. Long as that trace is there, their spirit is trapped or whatever."

"OK. So when the trace is gone, so are they?"

Jones turned to him. "Yup. You still a smoker?"

"Can't seem to get the monkey off my back."

"Let me have your lighter."

Gómez fumbled in his pockets for a second till he extracted a cheap plastic Bic. Nodding, he held it out to her.

With a watery sort of shimmer, a woman materialized beside him, her eyes wide with rage. She raked vicious long nails across his bare arm. He dropped the lighter and clutched his aching limb to his chest.

Jones did not hesitate. She darted her hand out the window, seized the hair, and then dove for the lighter. The apparition loosed a ghastly scream, her face twisting and distorting.

The female cop flicked the flame to life and lit the bloody strands.

Just as it hurled itself at her, the poltergeist fizzled away into nothing.

The cops stared at each other silently for a moment. Then Gómez cleared his throat.

"Uh, what do we tell people?"

His partner looked around them, her eyes falling on the broken window.

"We got locked in. I busted a window to call for assistance. That's it. No ghost, got it?"

Relief flooded the younger cop's eyes. "Ah, good idea. Who the hell would believe us, anyway?"

13
LA LOMITA CHAPEL

THE HISTORY

To the west of McAllen one comes across the picturesque town of Mission, whose origins are intricately bound up in the existence of a small chapel on a low hill (*lomita* in Spanish).

Upon his death in 1861, a French merchant living in Reynosa by the name of René Guyard bequeathed his land holdings to the Oblates of Mary Immaculate, a group of mostly French priests who had been servicing the spiritual needs of ranches throughout the area for more than a decade. This land comprised two Spanish *porciones*, or land grants: Porción 55 and Porción 57, the latter of which had come to be called La Lomita grant because of the hill on its westernmost edge.

The priests already had a relationship with the ranch on La Lomita grant, as they used a weathered old chapel there as a sort of base of operations, a halfway point between the missions they had established in Roma and Brownsville. This new property inspired Father Pierre Yves Keralum and Father Pierre Fourrier Parisot to think of multiple ventures that could strengthen their work. By 1884, they acquired Porción 56, the tract that separated the other two grants, and they set out to develop this two- by fifteen-mile extension into a competitive farm, ranch and community.

When the priests realized that managing the operation from Brownsville was not feasible, they decided to make La Lomita the headquarters of a separate Oblate mission district for the sixty-five ranches that make up what

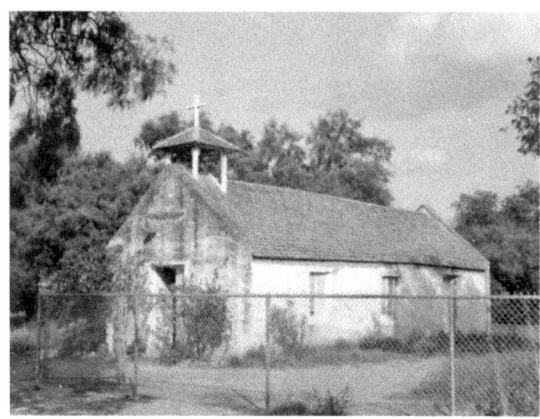

La Lomita Chapel before restoration efforts. *University of North Texas Libraries.*

is today Hidalgo County. On the low hill, a new chapel was built from stones extracted from local soil. Nearby, amid older wooden buildings, a brick residence was built for the priests. At a comfortingly close remove stood the humble homes of a handful of families who lived and worked on the property.

By 1907, the railroad had arrived, and state-of-the art irrigation systems were proliferating in the area. John J. Conway and J.W. Holt, wanting to establish a community along the lines of others springing up along the tracks, purchased most of the seventeen-thousand-acre tract from the Oblate priests, who retained one hundred acres in the nascent town itself as well as the three hundred acres by the river where the chapel and other buildings stood.

To honor the history of the site and its continued relationship with the Oblates of Mary Immaculate, Conway and Holt named their new town Mission. Three years after its founding, the order's headquarters were transferred to their property inside the city limits, and the older buildings fell into disrepair for lack of use.

Father Isadore Chateau understood that novice inductees into the order were better housed outside the town, so in 1912 the Oblates built a three-story building of brick for the novitiate on the hill beside the chapel. The program remained there for a half century before being moved to La Parra Ranch, after which time the building was briefly used to house a group of nuns.

As for the chapel itself, Chateau refurbished it in 1928 and again in 1939 to repair damage caused by a hurricane. Twenty-six years later, the site was registered as an important regional landmark in the National Register of Historic Places due to the vital role it had played in the early development of the Rio Grande Valley. A third restoration occurred in 1976, with the city

of Mission working to convert the surrounding land into a municipal park with a visitors' center.

As those visitors walked the verdant paths that circled the hill, they claimed to witness impossible things. And soon rumors began to spread about some unspeakable sacrilege that had spoiled that sacred soil.

The Legend

Robert Allen Ortiz and his girlfriend Stephanie Groves had graduated from Mission High School together and now were freshmen at the University of Texas Pan American. Though they came from very different backgrounds, they shared a love of shoegaze rock, Indian food and horror films.

One Friday morning, class having been let out early and neither of them having a job, the couple decided on a whim to visit La Lomita Chapel. They had grown up hearing all sorts of dark, gothic tales about the place, but they had never actually been to the site.

They picked up some chicken on the way there and then spread out a blanket near a shaded picnic area to have their meal. As they ate, they looked around at the buildings and speculated about what life must have been like back when it was all part of La Lomita Ranch.

"You see that ruined building over there?" Stephanie asked. "The brick one with the like towers on each side? That's where the nuns lived."

"Oh, yeah?" Robert raised an eyebrow. He figured she would bring the nasty old rumor up, but there was no use trying to cut her off.

"Yup. The messed-up thing is that, according to the legends my uncle used to tell me, some of the priests used to have, you know, carnal relations with them. When the nuns would get pregnant, these sicko priests would force them to abort or kill the babies after they were born. Some say they even buried their little corpses under the bricks in the chapel. Well, supposedly one nun fought against the bad priests, trying to save her kid. When they took it from her anyway, she committed suicide. And that's where the ghost comes from, the nun that people have seen hovering inside the chapel. She's keeping watch over her baby. The priests thought they'd get away scot-free, but people found out and stormed the chapel, dragging the priests out to lynch them."

Robert took a swig of Coke, trying to keep his cool.

"Are you done? Because, babe, I love you and all, but that's the biggest load of crap I've ever heard."

Stephanie blinked a couple of times.

"Excuse me?"

"Look, first off, that building was for men. Novices. Guys in training to become priests. I think it was like in the '60s when some nuns lived there, but it wasn't for that long. Definitely not enough time for evil priests to get a bunch of them pregnant and kill their babies. And about that. Pretty unlikely, don't you think? Someone would have found out. Priests would have been excommunicated. Or if the idiocy about lynching clergy were true, that would have been all over the papers. Look, I don't blame you. I know lots of people spread this urban legend. But reporters have point-blank asked the Church about the story, and it denies it completely."

A little flustered, Stephanie muttered, "It wouldn't be the first thing they've covered up. Maybe most priests are good, but there are bad ones, too. My history professor has talked about some of the atrocities of popes and stuff."

Shoving their trash into the box the chicken had come in, Robert got to his feet and went to throw it in the nearby garbage can. When he came back, he stood over his girlfriend, an irritated expression on his face.

"Look, all that happened hundreds of years ago. You're not Catholic, so you don't understand. The Church has reformed itself. It's not cool that people keep making all this sick nonsense up."

Stephanie rolled the blanket up and looked at him in anger. "Then why'd you even agree to come here? I thought you liked ghost stories. I figured you wanted to be creeped out by the phantom nun."

He shook his head. "Man, you really don't know me at all, do you? This is one of the oldest shrines to the Virgin in the Valley. I wanted to visit it to pay my respects, not so you could tear my religion apart."

Turning away, he began walking back to the car. She followed, muttering curses under her breath.

The disagreement opened a crack in their relationship that widened into a breach and then a chasm. Within six months, they had broken up. Just a few weeks later, Robert saw Stephanie walking past the library, hand in hand with some new guy. The sight was like a dagger in his guts.

Grappling with the sadness and anger he felt, Robert sat down and wrote out the true desires of his heart. Then he returned to La Lomita with determined purpose.

It was close to nightfall when he arrived. He stood beside the large, round outdoor oven for a time, watching the sky darken to royal purple. The statue

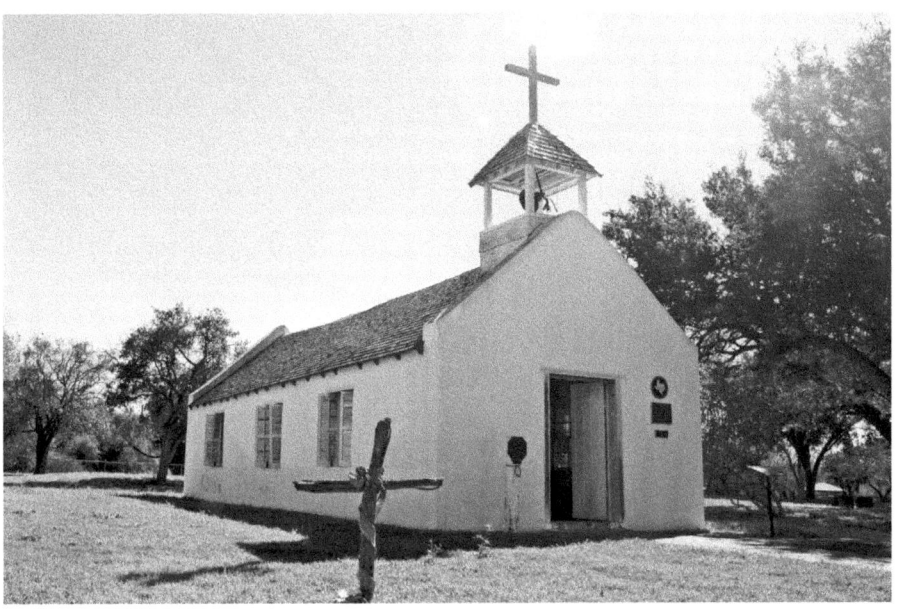

La Lomita Chapel. *Alexis Tran.*

of Mary Immaculate outside the chapel looked down upon him with eyes full of compassion.

A sob hitched in Robert's chest, and he stepped into the interior of the stone church. The white purity of the walls was broken only by wooden beams above and the dusty pews on either side. His toe snagged on a lose brick, and he knelt to pry it up.

The note was in his back pocket. He pulled it out, unfolded it and read it once more.

> *Mother of Heaven, please intercede on my behalf with your beloved son. I know I've made the right choice by ending my relationship with Stephanie, but the ache in my heart is more than I can bear. Spare me a bit of comfort, I beg you, just the smallest portion of your hope and love. Queen of Angels, defend me from the demons that would drag me into despair.*

He folded the prayer up again. On its back he had scrawled his initials and sketched a cross. He placed the paper in the hole in the floor and set the brick back in its place.

Standing back up, he walked to the rough-hewn altar and its image of the Virgin of Guadalupe. Ducking his head, he mouthed a novena.

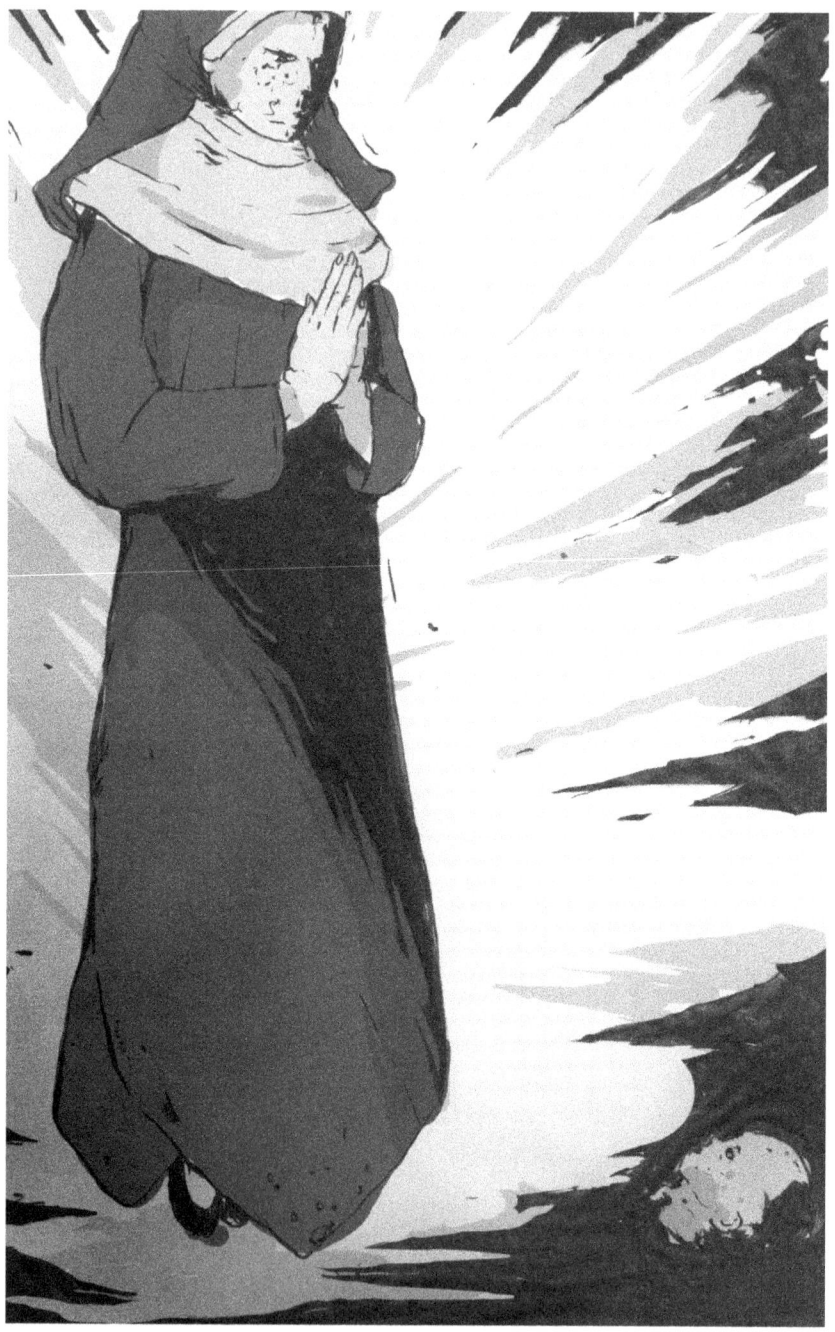

The ghostly nun at La Lomita Chapel. *José Meléndez*.

Behind him there came an eldritch sound, a glassy and hollow thrumming. Slowly he turned, his heart racing.

Floating a foot off the ground at the center of the chapel was a woman in a flowing robe, head covered, hands clasped as in in prayer. Her eyes were dazzling and ethereal. Robert dropped to his knees, overcome.

Then he saw them, clambering from the bricks below the apparition, the squirming souls of dozens of infants, mewling and blind, groping for sustenance in the failing light.

Darkness swirled all around Robert. He felt consciousness slipping.

And then, there was a curious change. He no longer saw the ghost of a nun floating above revenants of infanticide. No. Instead he understood this was Mary herself, praying for the broken spirits of her children, humankind, questing for the light of salvation.

The two interpretations of the vision flitted back and forth like some harrowing optical illusion. Was she a nun? Was she the Queen of Heaven?

In an instant of clarity, Robert saw the truth of this place could not ever be truly known.

This appearance was a test of faith.

He chose to have hope.

14

SHARY MANSION

Sometimes, they say, souls linger in a certain place not because of the tragedy that befell them there, but because of the enormous love they feel for the site. Such may be the case with John Harry Shary, whose attachment to the fertile soil of the Rio Grande Valley was inarguably powerful.

THE HISTORY

Shary's parents, Robert and Rose, had emigrated from Bohemia in the mid-nineteenth century and set themselves up as farmers in Saline County, Nebraska. They brought a girl and four boys into the world, the youngest of whom they named John upon his birth on March 2, 1872.

After graduating from high school, John went to college and became a pharmacist when he was just eighteen. Four years later, he had sold his successful pharmacy business and set out across the United States and Canada as a traveling lumber salesman, looking for opportunities in the area of land investments and development. Texas struck him as the most burgeoning of markets, and by 1910 he and his partner George H. Paul had purchased and developed a quarter of a million acres of land near Corpus Christi.

Having honed his skills for turning low-valued properties into successful sales, John Shary turned his eye to the Rio Grande Valley, where attempts

John Shary. *The University of Texas Rio Grande Valley.*

to grow citrus were having limited success. Taking note of the massive irrigation projects being put in place for other crops in the area, Shary felt certain he could turn deep South Texas into a citrus mecca, adapting existing mechanisms for large-scale commercial production to the particular issues of grapefruit and orange.

Moving to the Valley in 1912, Shary purchased and subdivided some fifty thousand acres via financing provided by Jesse H. Jones at the National Bank of Commerce. Among these parcels were most of the first experimental citrus groves, principally grapefruit. Shary used these as the starting point for an agricultural revolution.

He began small, with a modest local market for citrus fruit. But at his disposal were the tools with which to produce citrus on a large scale, and Shary did not hesitate. In 1914, he bought sixteen thousand acres of land bordering Mission, dubbing it Sharyland. The property comprised dense brushland, including thick mesquite, spiny cactus and other hardy local trees and shrubs. But crews of workers tore through the chaparral, clearing brush, digging canals and demarcating dirt roads. Within a year, Shary had begun to sell or lease forty-acre lots to would-be citrus growers.

By 1915, Shary had established the first large-scale commercial citrus orchard in the Rio Grande Valley. From his initial forward-thinking investment, a healthy citrus industry blossomed, shipping crates of oranges and grapefruits by train out of the Valley and to the rest of the nation. It was a bold venture that led to his being christened "the father of the Texas citrus industry."

At the nadir of the Bandit Wars, when property values began to plummet, Shary began to snatch up some of the holdings that John Conway wanted to jettison, such as a sizable irrigation project and twenty thousand acres of the La Lomita Ranch that Conway had acquired from the Oblates of Mary Immaculate. By that time, Sharyland—an unincorporated community, as it has continued to be to the present—was already attracting the wealthiest of businessmen throughout the Valley. As their families settled, education became a priority, and in 1922, the Sharyland Independent School District was formed, with John Shary as a member of the board.

The families and children spoke to a long-neglected need in the citrus magnate. He began to court Mary O'Brien, manager of the Omaha office of his International Land and Investment Company. They were joined in matrimony in a civil ceremony on November 13, 1922, and John brought his bride back to the sprawling home he had built beside a three-acre lake. Shary Mansion measured seventeen thousand square feet, with seven

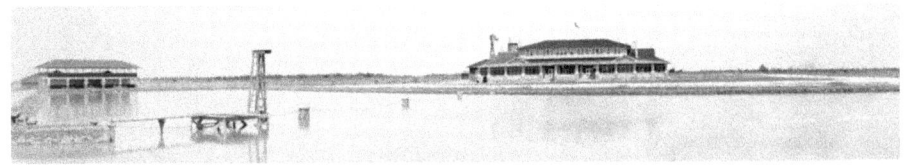

Shary Mansion and Shary Lake in the mid-twentieth century. *University of North Texas Libraries.*

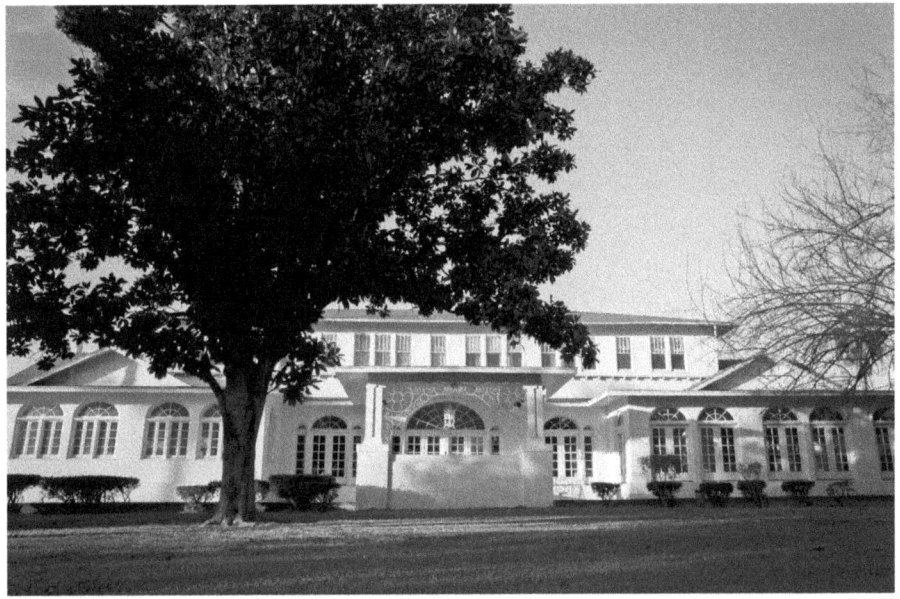

Shary Mansion. *Alexis Tran.*

bedrooms, a ballroom and a bowling alley, among other amenities. John made it a point to fill the stately rooms with flowers, especially magnolias, Mary's favorite bloom.

By 1924, there were two million citrus trees in the Rio Grande Valley, and Shary—after visiting California to research best practices in that state's industry—had joined together with the owners of other orchards to create a modern commercial packing plant in neighboring Mission: the Texas Citrus Fruit Growers Exchange. Still, something was missing from his life—an heir.

His wife could not give him a child, but in 1925, Marialice, the orphaned daughter of Mary's sister, came to stay with them. The fifteen-year-old became immediately and forever devoted to the Sharys, and

they formally adopted her when she turned twenty-one, giving her their last name. In 1937, Marialice Shary married Allan Shivers in a lovely and extravagant ceremony at the Shary mansion. Shivers would go on to become governor of Texas.

Eight years later, John Harry Shary died at the age of seventy-three. Newspapers throughout Texas and across the nation carried stories about his transformational effect on South Texas and the citrus industry. On November 8, 1945, two days after his passing, businesses in Mission closed for the afternoon so that the entire community could attend his memorial service.

Shary was buried per his wishes in a small chapel on his beloved estate. Fourteen years later, his wife was laid to rest beside him.

Legend has it, however, that John Shary's spirit will simply not move on.

The Legend

After the passing of the couple, Marialice Shary Shivers and Governor Shivers lived at the estate for many years, visited by personages as famous as Dwight D. Eisenhower and Dale Carnegie. Marialice remained very active in Valley affairs, serving on the Pan American University Board of Regents for thirteen years. Her surviving family later donated the estate to the University of Texas Pan American Foundation in 1997.

The issue with such a sprawling estate is the yearly upkeep, which set the foundation back tens of thousands of dollars each year. A solution finally came in 2012, when history buff and businessman Obed Flores purchased the property with an eye toward preserving the historical elements of the estate while simultaneously encouraging tourism by retooling the mansion into an events center and museum.

Many of the workers involved in the renovation were local carpenters, plumbers and electricians, like Estéban and Mark, who found themselves wrapping up a project one evening as the sky darkened into twilight.

"You know what they say about this place at night, don't you?" Mark said as they were stowing their tools.

"No. What do they say?"

"That John Shary haunts it. His spirit, I mean."

Estéban scoffed. "Whatever, man. Old wives' tales just to scare teens who might come messing around otherwise."

"Seriously. My cousin Isabelle says she saw him once."

"Was she drinking or something? Anyways, we need to head out. Bring that back and let's load everything onto the truck."

Outside, they got everything into the bed of Estéban's truck. The sun had disappeared, but the moon was bright. Mark gestured at the distant chapel.

"That's where he's buried, you know. Supposedly his soul leaves the tomb and comes across that road, walks right up to the porch and sits down in that old rocking chair."

The mental image made Estéban laugh out loud. "Right. What in the hell would a ghost want to sit in a rocking chair for?"

Mark shrugged. "Who knows? Isabelle figures he's waiting for something. Personally, I guess he just really loved this land. Poured himself into it, you know? Must want to check on it from time to time, see how the trees are growing."

Estéban opened the driver's side door. "You're a real weirdo, you know it, don't you? Come on, get in."

The men sat in the cab for a second while Estéban checked his text messages. Mark's eyes flitted back across the street, and his breath caught in his throat.

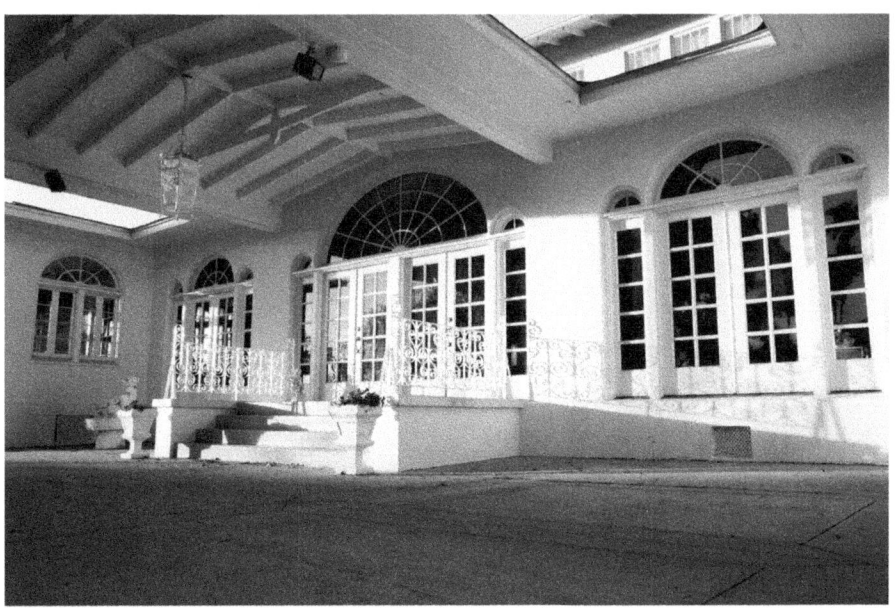

The porch of Shary Mansion. *Alexis Tran.*

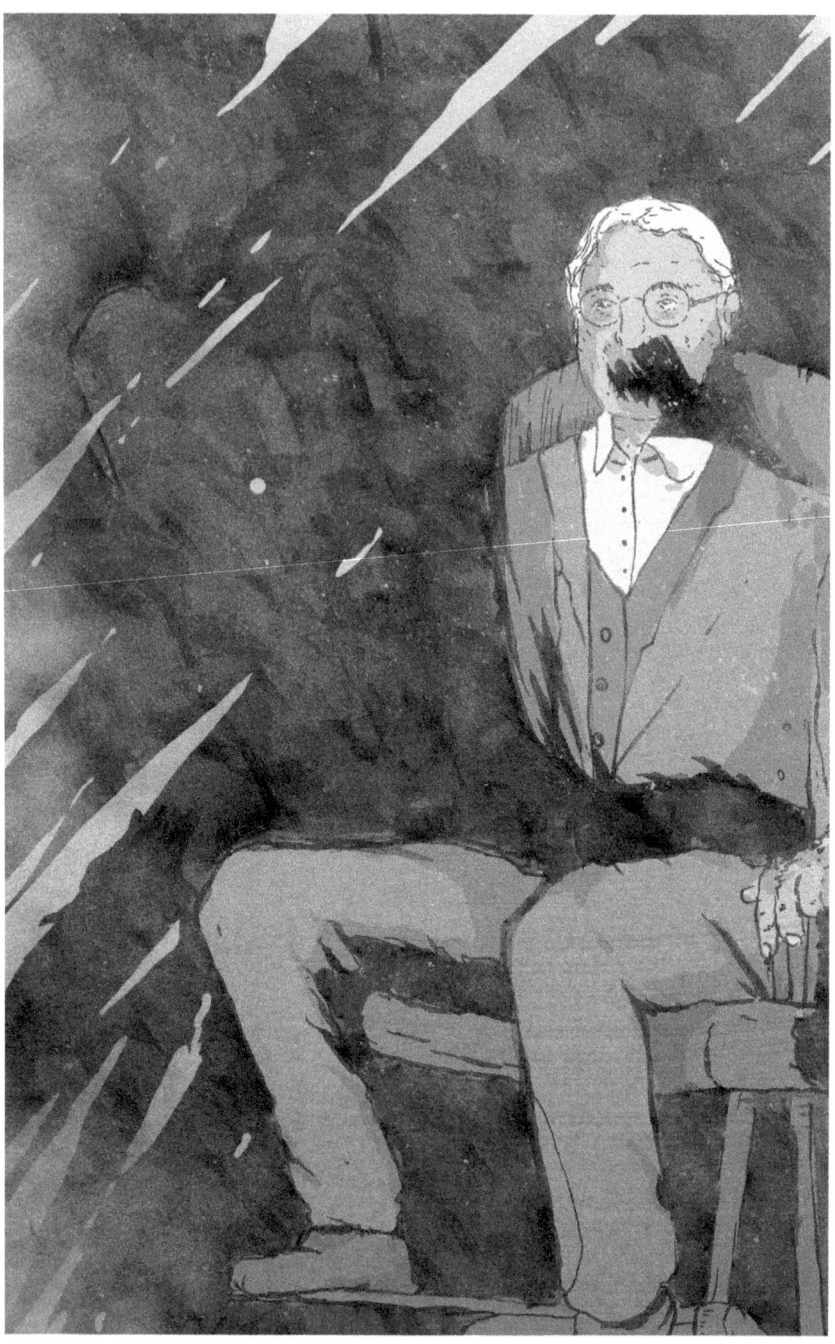

John Shary's ghost. *José Meléndez*.

"Dude," he whispered. "Look!"

Making its spectral way from Shary Chapel came the shimmering ghost of an elegantly dressed man. Floating a few inches from the ground, he drifted past the truck and its stunned passengers, heading for the ample porch of Shary Mansion. As the men craned their necks, the ghost settled into the rocking chair and began to sway back and forth.

"No freaking way," muttered Estéban.

"You're seeing him with your own eyes, friend. It's John Shary himself!"

Unable or unwilling to move, the workers sat for the better part of a half hour, watching the spirit gaze out across its former lands, an expectant look on its face. Then the ghost abruptly stopped rocking and moved like wisps of mist on the wind along the front of the mansion, disappearing around a corner.

"OK," Estéban said with a shuddering breath, "let's get the hell out of here."

"No, wait. Why didn't he go back to the chapel? What's he doing?"

Starting the truck, Estéban shook his head. "Don't care. Don't want to know."

But Mark had already opened the door. He slipped out into the night, walking as quickly yet quietly as he could. Rounding the mansion, he looked out at the broad lake behind it. Stars and moon glittered like diamonds on its surface.

John Shary was floating above the waters a few yards from shore. His right hand was outstretched, beckoning.

From the shadows beneath the trees came another figure, regal in a long dress that trailed behind her in the air.

It was Mary O'Brien Shary, Mark understood. She drifted out onto the lake and took her husband's hand.

Then there beneath the ribboned Milky Way, the ghosts began to dance.

STARR COUNTY

15
FORT RINGGOLD

THE HISTORY

On the other extreme of the Rio Grande Valley from Brownsville and the repurposed buildings of Fort Brown stands Rio Grande City and the remains of Fort Ringgold.

Rio Grande City, the county seat of Starr County, is one of the oldest settlements in the four-county area. It was initially part of the Carnestolendas Ranch, founded by José Antonio de la Garza Falcón in 1762 as part of José de Escandón's colonial efforts in Nuevo Santander. In 1847, Henry Clay Davis, an adventurous Kentuckian who had survived the Mier Expedition, married the founder's descendant María Hilaria de la Garza, who inherited the ranch and handed control of it over to her husband. Davis then established what would become Rio Grande City, though it was at first called Davis Landing or Rancho Davis.

On October 26, 1848, Brevet Major Joseph H. LaMotte arrived at Davis Landing with two companies of the First U.S. Infantry and a mission to protect the area from Indian and Mexican attacks. The army leased thirty-three acres from Davis and established what was called the Post at Davis Landing. Once some relatively flimsy installations were erected, the fort was renamed Camp Ringgold and later Ringgold Barracks in honor of Brevet Major Samuel Ringgold, the first U.S. Army officer to die at the Battle of Palo Alto, the first major engagement of the Mexican-American War.

From the moment of its establishment, Ringgold Barracks ensured permanence for the isolated community while also having a positive effect on the economic viability of the region by providing a sense of security against threats real and imagined. The post housed Starr County's first telegraph office, funneled federal funds into the local economy and kept violence in the area largely outside the city limits. Rio Grande City, as it came to be called, used the river to maintain a healthy passenger and cargo ship trade with New Orleans, Louisiana, as well as blossoming as a center for cattle husbandry and sales. The town also garnered the attention of the nation as Ringgold Barracks hosted a number of prominent military figures, including Robert E. Lee, John J. Pershing, and Jefferson Davis.

In 1859, businessman Cheno Cortina—who had risen up against Anglo oppression in the Rio Grande Valley—retreated up the river from Brownsville, pursued by Texas Rangers under the command of Colonel Rip Ford all the way to Rio Grande City. Ringgold troops were then under the command of Major Samuel P. Heintzelman, who joined forces with Ford and his Rangers to push Cortina deep into Mexico. During the prosecution of this "war," Lieutenant Colonel Robert E. Lee arrived at the fort to oversee the efforts. The building in which he lived while on site is known to this day as the Lee House.

At the outbreak of the Civil War in 1861, troops were pulled away from Ringgold Barracks. Four years later, it was reoccupied, and construction began on a permanent fort in 1869. By 1875, it had become one of the most attractive posts along the border, a series of frame and brick structures standing along a palm-lined parade ground, garrisoned by Captain Leander H. McNelly and a contingent of Texas Rangers. In 1878, the heirs of Henry Clay Davis sold 350 acres to the government, and the base they had erected there was renamed Fort Ringgold.

It is important to note that while the Anglo populace may have found the presence of the soldiers a welcome shield against violence from Mexico, the Mexican American inhabitants of Rio Grande City had a much more nuanced view. Starr County sheriff Washington W. Sheley had been implicated in the lynchings of several Mexican Americans over the years, and his heavy-handed tactics made race relations so tense that by September 1988, the community exploded into a riot.

The Rio Grande City Riot had its roots in Sheley's May 1888 arrest of Abraham Recéndez, a Mexican American resident of the town. Accompanying the sheriff at the time was Victor Sebree, U.S. inspector of

One of the remaining Fort Ringgold buildings. *Alexis Tran.*

customs. When Recéndez allegedly attempted to escape, Sebree shot and killed the man.

The killing gave rise to considerable public ire, fueled by anti-Sheley sentiment. Mexican American leaders sought to oust Sheley in the upcoming elections, so they used the incident and previous murders to argue that the sheriff was a racist. This group enlisted the aid of Catarino Erasmo Garza, a Mexican journalist in Corpus, to attack Sheley, Sebree and their colleagues in a series of editorials published in the newspaper *El Comercio Mexicano*, in which Garza laid out the case that Sebree had assassinated an unnamed Mexican American prisoner.

To better cover the election and its racial undercurrent, Garza traveled to Rio Grande City, only to be arrested viciously by Rangers for a ridiculous "publishing crime." He was eventually released, miles from the city, to which he had to walk in humiliation. On the morning of September 21, Victor Sebree approached Garza on horseback as he sat in the doorway of a barbershop. After Garza refused to fight him, the customs inspector dismounted to shoot and injure him. Two hundred indignant residents flooded the streets that day demanding justice. When there was no satisfying response from the government, they threatened to lynch Sebree, chasing the fleeing man all the way to Fort Ringgold, where the post commander ordered them to disperse. They complied.

It was too late. Despite the injustice of Reséndez's death and Garza's wounding, the prospect of Mexican American mobs was much more horrifying to the Anglos in town. News reports sprang up across the United States about a possible race war breaking out in Rio Grande City. The governor of Texas began to receive a veritable flood of telegrams and missives about the violence in Starr County, begging for his intervention to protect white lives. Between the troops at Ringgold, the sheriff departments of all counties in the Valley, a group of soldiers of the Third Cavalry and other sundry militia outfits, the state and federal government poured hundreds of armed men into the streets of Rio Grande City.

All remaining hints of additional riots dissolved before such a brutal show of force. Victor Sebree, however, retained his job as U.S. inspector of customs.

Discord between Fort Ringgold and Rio Grande City reached a boiling point in 1899, when Troop D of the Ninth U.S. Cavalry was stationed at the fort for a time. The African American troops, having triumphed in Cuba, were incensed by racial restrictions and harassment in town. Tensions ratcheted tighter and tighter as rumors flew about possible assaults on either the town or the fort by those on the other side of the conflict.

On the night of November 20, post commander Second Lieutenant E.H. Rubottom received reports that the garrison would soon be under attack by residents of the town. In response, he ordered his men to fire the Gatling gun on the area between the post and town. Only one local was injured, but the action served to quell the violence. After an official inquiry, it was determined that while Rubottom's actions were probably premature and foolish, he should not be formally charged.

Many residents, however, along with others throughout the Valley, were convinced that the soldiers had faked the assault in order to teach the community a lesson. Troop D was withdrawn not long after the incident. The fort itself was closed in 1906 as a result of military exigencies in the Philippines, but by 1917, it had been reoccupied due to fears arising from the Mexican Revolution and Bandit Wars, with Congress voting to provide funds for improvements to the site.

Thirty years later, the army decided the time had come to permanently close the fort. It was declared surplus, and most of the property was disposed of. Human remains from the Fort Ringgold cemetery were moved to the Fort Sam Houston National Cemetery in San Antonio. In 1949, the Rio Grande Consolidated Independent School District purchased

The Fort Ringgold barracks in the mid-twentieth century. *University of North Texas Libraries.*

the property and has maintained most of the buildings to the present, including the renowned Lee House.

As more and more civilians wandered those grounds, reports of dismal shades, clinging to the place of their death, began to filter through Starr County. The consensus is clear—Fort Ringgold is haunted.

THE LEGEND

It was a late spring morning in 1990 when eighth graders Arturo Sandoval and Leticia Blanco slipped from their middle-school campus in Rio Grande City, having decided the day was too beautiful and they were too much in love to be sitting through mathematics and science. Leti was a little nervous about skipping class, but they managed to evade the cursory watch kept by teachers and administrators in order to make their escape.

"It ain't far," Art said as the campus receded behind them. "Just act natural. Quit looking all around, babe."

"I can't help it. My dad'll kill me if we get caught."

"We ain't getting caught. I swear it." He took her hand in his and smiled. Leti swallowed her fear and smiled back.

Soon they had made it through the meager camouflage of mesquites clumped along a block of Clay Davies Street in what remained of old Fort Ringgold, its buildings and barracks adapted down the years for use by the school district. Emerging onto a parking lot, they quickly scurried between two steel buildings and stared from the shade.

There it stood on a low hill carpeted by unnaturally green grass, clapboards almost leprous with peeling white paint and black dots of rot: the Robert E. Lee House, its strange double roof hunching down against the ever-warming sun.

"They say General Lee lived here back in 1860," Leti whispered, nearly in awe. "He came to deal with Juan Cortina and all the raids he was doing."

Art shrugged. "Girl, Cortina was a freaking hero. Dude was trying to stop oppression and stuff. Like Robin Hood and César Chávez rolled into one. You never heard his corrido? My tío has it on cassette. It's bad. Besides, who cares what some slave-loving general did?"

"This was before the Confederacy, Arturito. He was still working for the U.S. military."

The boy shrugged. "*Chale*. Whatever."

Hand in hand, they dashed to the historical landmark.

"Come on, get on through," Art instructed, lifting the fence up where it had been clipped a few years back. He squeezed in after her.

They mounted the hill together and climbed the steps to the porch that ran along the outside of the old home. Art's friends had told him which window could be opened, and the couple was soon inside the stuffy gloom, leaning against each other as light slanted through the room in dusty beams.

Leti clinging to Art's arm, the adolescents toured the empty house in silence. It was pretty unremarkable; tenants living there during the past hundred years had remodeled its interior many times, so it did not look antiquated, merely old.

They stopped in the kitchen, and Art leaned in to give his girl a kiss.

"No, don't. I'm nervous. They say this place is haunted."

He waved her fears away. "*Puro cuento*. Grown-ups say that stuff so kids won't come here. But my friends ain't ever seen a ghost, babe, and they been here lots of times."

Leti pulled away from his embrace. "Yeah, well, all of this used to be old Fort Ringgold, and my abuela says the spirits of the fallen soldiers still roam the place, especially the unknown soldier."

Art smirked at her. "Babe, even the teachers say that's all lies. Last year, when you were still up in Minnesota, Mr. Reyes took us on a field trip to look for the grave of *ese mentado* unknown soldier."

"What grave? They moved all the corpses when they shut down the fort back in the '40s."

"*Exacto*. Still, people say there's this unmarked grave somewhere, with a soldier inside. But Reyes said the dude wasn't a soldier. He told the class that like in 1888 this jerk named Sebree, friend of the white sheriff, killed a Mexican American prisoner 'cause supposedly he was trying to escape. Yeah, right. Sebree had already lynched other Mexicans, so everybody got super mad and started rioting."

Leti nodded. "Sure, I know the story. Even though the townspeople finally broke up and went home, folks around the country were scared at a bunch of us demonstrating like that."

"And they sent more troops. So people died. That's who Reyes said is in that tomb. Not some unknown soldier, but the last rioter, he got himself executed by a firing squad 'cause he shot somebody important."

Leti shivered. The kitchen had gotten suddenly cold.

"No matter what the truth is, Arturito, their spirits could still be trapped here. Let's go back to school."

Death of Major Ringgold, of the Flying Artillery, at the Battle of Palo Alto, May 8, 1846. *Library of Congress.*

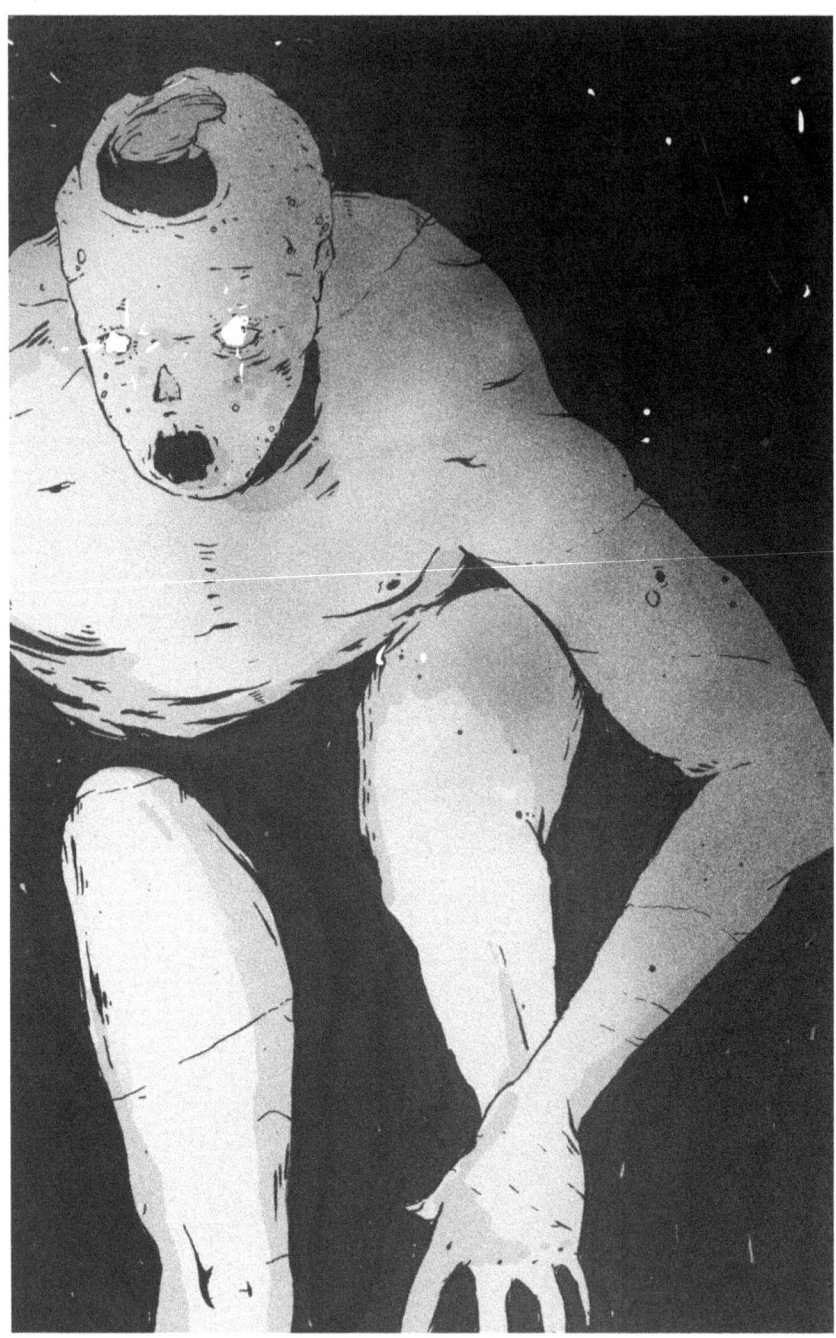

A ghost at Fort Ringgold. *José Meléndez*.

"And get sent to the principal's office? *Chale, flaca.*"

He bent to kiss her again, oblivious to the misty breath that curled from both their mouths.

"Don't be afraid. I ain't letting no ghost mess with you."

At his words, all the cabinet doors in the kitchen burst open. Drawers pistoned in and out in jerky, syncopated rhythm. The floorboards beneath the couple's feet began to groan.

Leti screamed in horror.

Seizing his girlfriend by the arm, Art pulled her from the kitchen. They ran through the house toward the room with the unblocked window, but the door slammed in their faces. The baseboard along one wall whipped away with a snapping sound, nearly crashing into Arturo's head.

Soon the whole house was shaking, a frigid wind slashing back and forth through its empty yet haunted spaces. Arturo pounded and kicked at the door to no avail.

Leti, her heart thudding, suddenly had an idea. She stepped into the center of the living room and began to speak.

"We . . . we're sorry to come without permission. We know you're mad. It . . . it wasn't fair, what happened to you. It was an injustice, a tragedy. But listen: *somos de los suyos*. We're one of you, okay? Let us leave, and we'll honor you. We'll let people know that good men and women were killed in this town for speaking their minds. We won't let them forget you."

The cold air fell still for a moment. Then it compressed with an audible whoosh till there before the youngsters in the living room floated the glowing, silvered contours of a man. He stared at them with icy eyes for a moment, then turned and gestured at the door.

It opened onto the sunny warmth of early afternoon.

The poltergeist was letting them go.

Once outside, Art hurried away, anxious to put the house and its ghostly inhabitant behind him. But Leti could not help but turn back once more. The revenant drifted faintly in the shadows of the porch, features twisted with a century's worth of grief and indignation.

Leticia Blanco could not bear the sight. Burying her face in her hands, the girl wept for all the fallen innocents of the world.

16
LABORDE HOUSE

THE HISTORY

François LaBorde was born on April 16, 1867, in Arudy, France, to Jacques LaBorde and Marie Candau. Far-thinking even as a boy, he traveled up the Rio Grande by steamboat in 1878 after crossing the Atlantic, presumably in the company of some relative. After settling in Rio Grande City, he began to work hard and build a reputation for himself, returning briefly to his homeland in 1883 and spending quite a bit of time in Mexico. He picked up very little English, but Spanish he mastered as well as his mother tongue.

In 1890, François—who now called himself Francisco—opened a general store in Rio Grande City unique in its connection to the Old World. Given the popularity of leather gloves in Europe, he made quite a bit of money exporting tanned hides to French glove makers. During a visit to France in 1893, a now well-to-do LaBorde hired an architect to design a home for him that would evoke the majesty of Paris. A San Antonio architect gave the plans a second pass, and then began a six-year process of importing materials and furnishings from Mexico, Louisiana and France to build his dream home.

His desire for such an opulent home and intense attention to details stemmed from his romance with Eva Marks, who had been born in Rio Grande City in 1879 to a French father and Mexican American mother. LaBorde married Eva on March 2, 1896, at a ceremony in Starr County.

Starr County

Francisco and Eva's first daughter, Blanche, was born a year later, on March 10, 1897. Four more children came into their lives over the next ten years: Frank (1901), Leonard (1903), Lionel (1907) and Ernestine (1910). Because of LaBorde's mill and other enterprises, the family had close ties with San Antonio. In fact, his wife and their five children spent most of their time at the family's home in Alamo City, while LaBorde lived in their palatial Parisian-style house in Starr County, where the majority of his businesses were located. Yet they were more united than this might suggest, with both husband and wife traveling back and forth between the two homes.

For his community, LaBorde became a sort of eccentric, beloved figure of the elegant vanguard. His was the first automobile, the first electric stove, the first house with indoor plumbing. But as he embraced the future, he also reached into the past, celebrating his own French roots while celebrating the Mexican culture prevalent in the area. This paradox endeared him to the people of Rio Grande City, who loved to gossip about his aristocratic airs—his patronage of theaters and opera houses, his cellar full of fine foreign wine, the French flag fluttering outside his home. Yet they acknowledged his place as a peer in their community, dubbing him Don Pancho.

Yet there were moments of darkness for the family. Blanche, the eldest of the LaBorde children, graduated from the College and Academy of the Incarnate Word in San Antonio in 1914 and returned to live in the Rio Grande City home. She was living alone, however, for her father was in San Antonio, staying with his wife and other children while grappling with a debilitating condition. Blanche managed to handle his business affairs in his absence, but Don Pancho would never fully recover from this illness.

Blanche eventually eloped with a young man her age named Frank Chapa, devastating her parents for a time. The family had always worked together as a team, and her striking out independently without their input was a difficult change. In time, they adjusted, and LaBorde decided to convert their Starr County estate, the symbol of his family's roots and unity, into an elegant hotel simply known as LaBorde House. The sophisticated lodgings opened in 1917, quickly becoming a home away from home for traveling elite and weary working folk alike.

One of the most peculiar aspects of this expansion and conversion is the hidden tunnel that was either dug at the time or tapped into by Don Pancho for inscrutable reasons. From the courtyard, a spiral staircase curved away into deep gloom below. Descending, one found oneself in an underground passageway that ran for more than a block to the banks of the Rio Grande

Valley, which at the time—before Falcon Dam had been built—lay about one thousand feet away.

Rumors abound about the possible sordid uses of this tunnel, mostly centering on the notion of a black market economy of goods, coin and people that could be transported directly to and from the hotel and shipped all over South Texas. It is said that Al Capone had local connections that ran alcohol through the passage at the height of Prohibition. Other stories suggest the tunnel dates from the Civil War and was used to get around interdiction on slave trade.

Less fanciful minds acknowledge it as a probable escape route for the much-feared uprisings or bandit attacks. Canoes were always at the ready on the river near the exit point, providing guests with a convenient getaway in the event of an emergency.

LaBorde's joy at his new endeavor faded as tragedy struck. Tradition has it that the parents of a child with polio were staying at the hotel, employing the cistern in the courtyard for the child's therapy. A pair of little girls, curious about the cistern, wandered too close, falling in and drowning.

Not long afterward, on the morning of August 11, 1917, Francois LaBorde was found dead in the room known today as the Audobon. Whether to flee from an encroaching disease or from guilt over the children's death, Don Pancho had committed suicide, shooting himself in the head. He was interred the very next day somewhere in Rio Grande City, but inexplicably the place of burial was not recorded.

It was a horrible blow to the family, but Eva and the children forged ahead, taking over the management of the hotel as long as they could. The city itself reeled from the loss. In 1925, Rio Grande City reported a population of 3,000, and residents voted for official incorporation. But the Great Depression hit hard. By 1931, there were only 2,283 people living in the community, which had gone into serious debt making improvements to the town. Residents voted to unincorporate in May 1933 to avoid repaying the debt.

Eva LaBorde felt the economic pressure as well, and in 1939, she had no choice but to sell out to George Boyle and General James S. Rodwell, who renamed it the Ringgold Hotel, managing the historic lodgings until 1982. Many famous personages slept in those elegant beds, from Lady Bird Johnson to Robert Kennedy and César Chávez. Mrs. Johnson was so enamored of the place that she helped get the Meadows Foundation to aid in its restoration in 1982, when Larry Sheerin of San Antonio bought the Parisian home.

LaBorde House in the late twentieth century. *Texas Historical Commission.*

In 1991, LaBorde House was purchased by the Starr County Historical Foundation, which oversaw a careful and intricate restoration project in partnership with the Texas Historical Commission to restore the hotel to its original condition and appearance using records and photographs to invest more than $1 million to recapture the look of a luxurious home at the end of the Victorian era.

Today, the impressive historical site has seven bedrooms that guests can book.

Of course, the catch is that they will not be in those rooms alone.

LaBorde House is haunted, you see.

The Legend

Employees of the Starr County Historical Foundation and others who work in LaBorde house are the first to nod at reports of the paranormal. They themselves have seen apparitions, heard footsteps and even been

physically touched by what seem to be human spirits. And, of course, they have fielded multiple calls from visitors confronted with the supernatural elements of the hotel.

Different rooms and areas of LaBorde House evince hauntings by distinct beings, all tied to the site by some tragedy that befell them there.

A mere mention of the Red Room sends chills down locals' spines. Even elementary students in the community know about those carmine quarters. When Fort Ringgold was still open, the soldiers stationed there often sought surcease and satisfaction in the arms of an elegant prostitute known to all as the "Lady in Red."

Smelling sweetly of roses, a lovely crimson gown clinging to her welcoming curves, the Lady in Red would sit in the courtyard of LaBorde House on certain evenings, waiting for a lonely soldier to approach and accompany her to her preferred room, a sumptuous spread done up in scarlet and vermilion.

As fate would have it, the Lady in Red found herself falling in love with a young lieutenant who had recently been posted to the fort. The weeks progressed, and she stopped taking customers, desiring only to spend every moment she could in the company of her beau.

"We'll marry," he whispered to her one night as they stared out over the river. "I'll take you away from here, far away, to where no one knows who you are or what you've done."

"Nothing matters to me," she sighed in response, "except being with you. Wherever you wish. However you desire."

Ah, but the lieutenant was a liar. A fiancée awaited him back home, and he had no intention of taking his new lover anywhere at all.

One week, he did not show up for their scheduled tryst. Desperate and afraid, the Lady in Red traveled to Fort Ringgold to inquire after his health and whereabouts.

"The lieutenant has shipped out," she was told. "His wedding is next week."

The news broke her. Closed up in her red room, the spurned and deceived woman let despair gradually worm its way into her heart.

One morning, the sun glittering blood red in the eastern sky, the Lady in Red stood on the railing of her balcony, tears streaming down her rouged cheeks, and jumped to the street below.

Now, nearly a century after her death, some of those who stay in her room claim they have heard her footsteps in the room, not stalking, but keeping eternal vigil. Others have seen that sad face peering out at them from the bathroom mirror.

She gives a wistful smile, and the room is filled with the poignant scent of roses.

The Ringgold, also called the Kids' Room, served originally as the bedroom of the youngest two LaBorde children when their mother brought them to Rio Grande City. Once the home had been converted to a hotel, it was the site of the final few days in the lives of the two girls who drowned in the courtyard cistern.

It seems their spirits linger there.

Once, a guest staying in the room was awakened in the middle of the night by the sound of young voices, crying weakly for their mother. Splashing drew the awakened visitor to the balcony, but the cistern was still and the pitiable shouts faded into the darkness.

Another time, a man had booked the room next door to the Ringgold. As he tried to sleep one evening, he was disturbed by the sound of children running around on the other side of the wall, bouncing on the bed and laughing uproariously.

After pounding on the wall a few times to no avail, the man called the front desk and complained.

"Excuse me, but could you call the room next to mine? Their kids are being pretty loud, making a real ruckus."

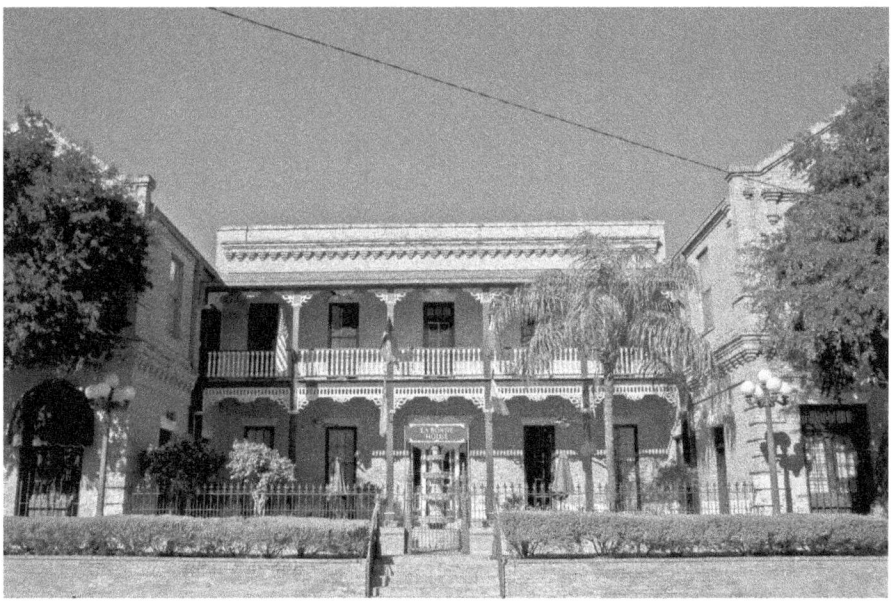

LaBorde House after recent renovation. *Alexis Tran.*

"I'm sorry, sir," the hotel employee replied. "You're the only guest in the hotel tonight."

Within ten minutes, the man had checked out of the hotel, muttering about rambunctious ghosts.

The Texian bears an ironic name.

Employees and guests alike find the room off-putting and troubling, as if something unaccountable horrible were watching and waiting in the shadows.

Also known as the Blue Room for its color scheme, the space is dominated by an oversized four-poster bed. The legends tell of an aging cattle baron who had lost all three of his sons in World War I. Overcome with grief and rage, he snapped, killing his wife and taking refuge in LaBorde House.

But the spirits of his loved ones followed him there, tormenting him all through the night as he huddled like a child at the center of that huge bed.

When dawn broke bloody and savage on the horizon, the cattle baron got up from the bed and hurled himself to his death through one of the windows. His body was found a few hours later by one of the maids.

On his face was a horrifying rictus of mad despair that haunted her until her own death decades later.

The tunnel should be off-limits, but not everyone who books a room at LaBorde House likes to play by the rules. A young woman obsessed with the paranormal once stayed at the hotel, sleeping in the Audobon in hopes of glimpsing the ghost of Don Pancho, his skull bearing the ethereal print of the smoking hole that the gun had left.

Several uneventful hours passed as the hotel slipped into the silence of deepest night. Grabbing her cellular phone, the woman went downstairs and out the door to stand beneath the moon in that creepy courtyard.

The spiral staircase leading to the tunnel fairly loomed at her in the silvery glow, beckoning, enticing her to explore. Flipping on the flashlight app, she slowly descended the cobwebbed steps until she stood in the tunnel whose exit the city had sealed decades previous.

She passed illumination over the damp walls, shuddering at how insects and lizards scurried from the light. Her imagination wandered. She pictured illicit alcohol passing in crates down the tunnel, prostitutes being smuggled in and out for discrete liaisons, patrons huddled in fear of some new raid from across the river.

A groan sounded softly in the inky emptiness ahead. Her phone could not penetrate the tenebrous murk, so she took a few steps, then a few more, questing ever forward, her heart pounding with irrational fear.

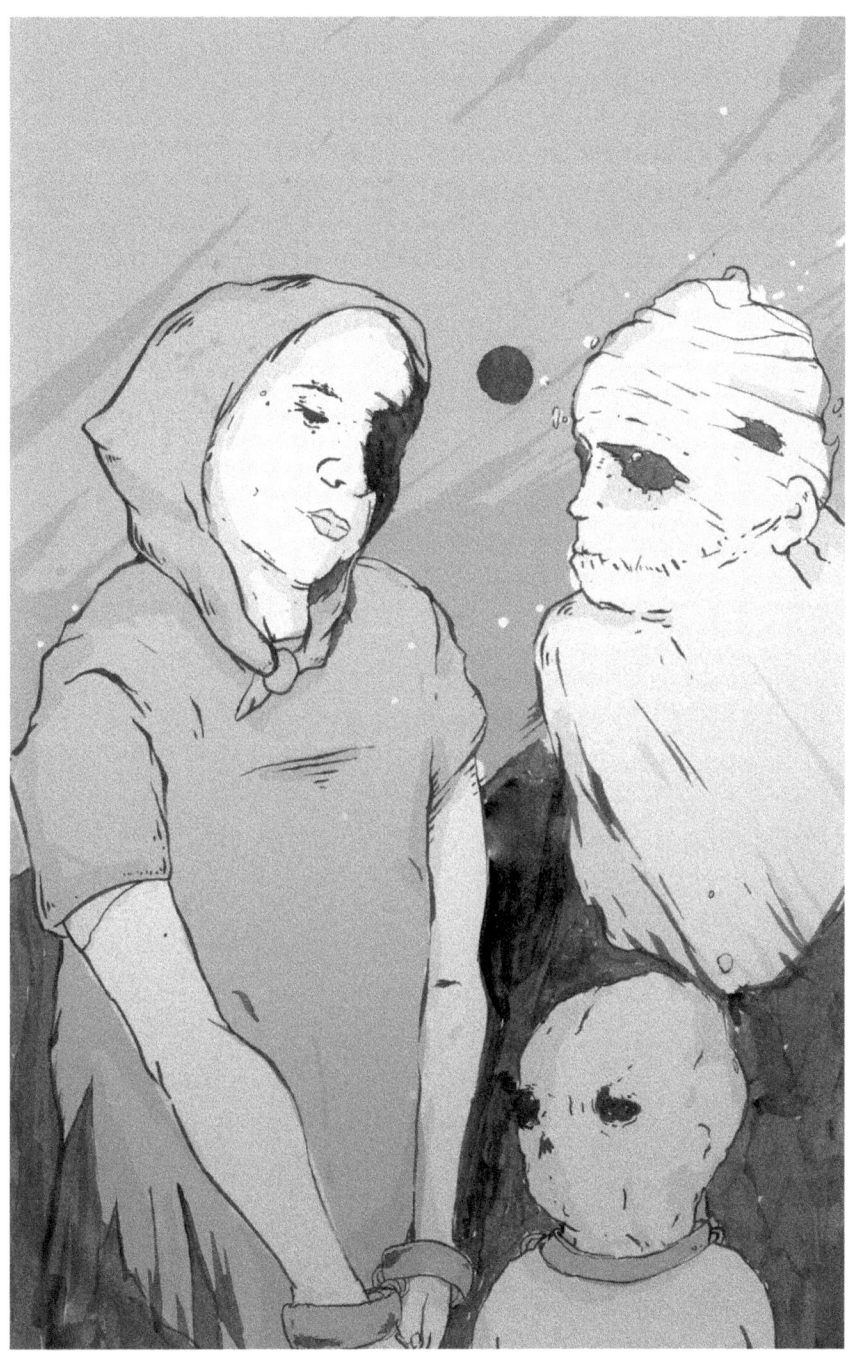

A phantom family in the tunnel beneath LaBorde House. *José Meléndez*.

Three figures, stooped and shuffling, coalesced in that passageway. They lifted shackled hands to her in supplication, their emaciated forms clearly beaten and bruised.

A family of slaves, either escaping or being driven again into bondage. Their wordless moans rose in volume, and the young woman found that she could not stay another second. Spinning to run blindly back up the tunnel, she ascended the stairs and emerged sobbing into the cool night air.

Up close and personal, the paranormal was less appealing than she had imagined.

Ghosts, she realized, are like scars on the skin of the world, wounds that have healed but whose ugly marks remind us of our most sinful deeds.

17
THE WOMAN IN WHITE AT ROMA

THE HISTORY

Roma—also known as Los Sáenz or Roma–Los Sáenz—stands at the westernmost edge of the Rio Grande Valley on Highway 83. Serving a port of entry athwart the Rio Grande, Roma fronts its sister city in Tamaulipas, Mexico, Ciudad Miguel Alemán, Tamaulipas. The town was formed when two adjacent settlements, Roma and Los Sáenz, merged in the nineteenth century in what had been the Spanish province of Nuevo Santander.

The first settlement in the area was Corrales de los Sáenz, a ranch founded about 1763 by the Sáenz brothers—Miguel, Gerónimo and Juan Ángel—who had followed colonizer José de Escandón from the colonial city of Mier. The community comprised a large section of both Porciones 71 and 72, which the Spanish crown granted in 1767 to Juan Salinas and Juan Ángel Sáenz. The land in these grants was at first under the jurisdiction of the Mexican city of Mier, as was San Pedro de Roma, established on the south bank in 1821.

A river crossing known as El Paso de la Mula (Mule Pass) sprang up near the site, allowing goods and people to flow freely from one bank to the other, convenient given the vibrant salt trade between the area and Monterrey. When Mexico won its independence from Spain, the porciones became briefly part of the state of Tamaulipas. With the establishment of the Republic of Texas in 1835, the area came to be known as Buena Vista and then García Ranch.

In 1848, when Texas was subsumed by the United States, one of the communities on the ranch was officially called Roma, a name suggested by the Oblates of Mary Immaculate, who then founded their second Valley mission there in the 1854. The settlement boasted the only post office in Starr County at the time.

Despite the battle fought at Mier during the Mexican-American War, Roma remained part of Texas. By 1850, it had merged with the neighboring village of Los Sáenz to form Roma–Los Sáenz. During the American Civil War, the region experienced an economic boom due to the export of cotton, which sidestepped Union blockades by passing through the Valley into Mexico and then on to Europe. Roma-Los Sáenz was the westernmost port on the Rio Grande for the flatboats and steamers that transported Confederate cotton to the Mexican port of Bagdad. After the South lost, the economic strength of Roma–Los Sáenz waned. Development upstream and the damming of the river lowered water levels and made passage by steamboats impossible. Without access to railways, Roma–Los Sáenz began to stagnate. By 1904, it had a population of only 521 souls.

It was a shame. The town was considered a real beauty, dominated by a church built by former carpenter Oblate Father Pierre Keralum, the convent of the Sisters of the Incarnate Word and notable homes like the Pink House and the Manuel Guerra home, both designed by German architect Heinrich

Roma's historical plaza. *Alexis Tran.*

"Enrique" Portscheller. At the apex of the Mexican Revolution and political unrest in the Rio Grande Valley, many persecuted people sought refuge in that same Pink House, by then converted to the Knights of Columbus Hall.

Economic hardship slowed and began to turn around when in 1925 the railroad reached Rio Grande City and new roads were laid between that town and Roma. Then, during the 1930s, petroleum reserves were discovered near Roma, drawing many new workers and their families to the area, doubling the population in short order.

Roma reached celebrity status in 1952, when Anthony Quinn and Marlon Brando were in town filming *Viva Zapata!* under the direction of Elia Kazan. The town had been selected because its historical plaza had remained so achingly evocative of Spanish colonial times. Local residents were hired as extras for ten dollars a day during the sweltering summer shoot, which injected considerable cash into the economy.

Even as those Hollywood stars walked the dusty streets of Roma, the old folks say, the Lady in White had already begun to wander the plaza all through the night.

THE LEGEND

Isabel Salinas had always shown a measure of devotion to the Church and piety that her sisters could not rival. It was no surprise to her parents, then, when as a teenager she expressed a desire to dedicate her life to the service of Christ.

Mr. and Mrs. Salinas accompanied their daughter to the parish hall, which housed the convent of the Sisters of Mercy, on the northwest corner of the plaza. The mother superior greeted them warmly. Already well acquainted with Isabel's pious heart, she accepted the young woman with little hesitation as a postulant.

"In six months' time," she assured Isabel, "God willing and your heart proven, you will don the habit of a novice and enter training."

The young woman was ecstatic. In addition to her normal duties at home and her service to her community, she began spending a few hours each day within the partial seclusion of the religious compound, carrying out minor chores and learning of her eventual life in the novitiate.

She came to love the physical presence of the convent, the one-story brick building with its restrained classical aesthetics, its steeply pitched roof, the

façade porch she so diligently swept each evening, the balustrades of the cupola's deck. It struck her as the very sober embodiment of the sacred charge she longed to embrace.

One day, letting the breeze dry droplets of perspiration from her brow as she stood in the more secluded rear area of the grounds, she felt someone's gaze. Turning her eyes north, she saw a man staring at her over the five-foot wall and through the glossy green leaves of the ebony trees.

"Hello, ma'am," he called in English. "Didn't mean to startle you. I'm just new here and mighty curious about everything."

"Oh, welcome, then," Isabel replied. "I hope you enjoy your stay."

He smiled, and something strange unknotted within her chest. "Name's Daniel Garza. I'm from San Antonio, but a job opportunity in the oil business brought me to your fair city."

"Nice to meet you, Mr. Garza. My name is Isabel Salinas."

They spoke a little longer over that wall about Roma and its amenities, and then Daniel took his leave.

A few days later, he walked by the convent again, exchanging a few pleasantries with her. Before long, this had become his custom, and Isabel found the brief conversations agreeable. When they chanced to see each other at Mass, Daniel would send the most courteous and chaste of nods her way. He was proper and polite, and she told herself that she was simply being a good neighbor and Catholic by speaking with him.

Then came the week that he did not visit the plaza, and Isabel's heart tightened with each passing day, imagining horrible accidents with the machinery his job required him to operate.

The relief she felt when he his face finally peeked over the top of the wall was a cause for both joy and regret. She understood in that moment that she was in love.

Daniel explained that he had been back in San Antonio, visiting with relatives from Spain who had brought him up to date on the civil war that was exploding as Francisco Franco's Nationalists swept across the country with their fascist zeal.

"It's a horrible situation," he told her. "Spain needs international help, but few countries want to intervene. I think that's a real mistake. This sort of crazy thinking is bubbling up all over the place, and we all have to fight it to keep our liberty."

His zealous desire to defend his principles and the lives of others made him that much more appealing to Isabel. She prayed long and hard about her feelings and realized that God was pulling her in a different direction.

Our Lady of Refuge Catholic Church on Roma's historical plaza. *Texas Historical Commission.*

Before speaking to Daniel or her parents, she approached the mother superior. She smiled and patted the young girl's hands with affection.

"Perfectly all right, my daughter. This is precisely why we have prospective nuns spend time as postulants. Your calling is elsewhere. I respect your willingness to face that truth."

The following afternoon, she was waiting for Daniel outside the site where he was employed. A look of first confusion and then dawning happiness washed over his face. Walking briskly, he took her hands.

"It's . . . it's more than I could have hoped for."

Isabel smiled. "We bend to the will of our Father, Daniel. Even where the heart is concerned."

The next few weeks were difficult, as Isabel announced her decision to abandon her earlier goal and Daniel came to ask for her hand in marriage. The young man was charming, however, from a Catholic family in good standing in the Alamo City, and her parents soon warmed to the courtship.

Christmas came and winter stretched weakly into the Valley as the town of Roma ushered in 1937. A date had been set that June for the wedding, and Isabel spent hours with her mother and sisters, designing and confectioning a lovely white dress in which to say her eternal vows.

Her elation was so great that it took her a moment to process the look on Daniel's face when he came to visit her. Determination had set his jaw tight, but his eyes shifted with a sense of remorse or guilt.

"What?" she managed to ask, her stomach fluttering with prescience.

"It's the Nationalists. They've put out a call for assistance. A group of Americans and Canadians are heading over to form up a battalion. I . . . I need to go. I have to help."

Isabel quailed, her hands reaching for him. "No, wait. It's not your fight, Daniel."

"Yes, it is, my love. It's everyone's fight. I wouldn't be able to live with myself if I did nothing to stop the rise of a dictator."

"But . . . the wedding!"

"I'll be back by June, Isabel. I swear it. Just . . . let me go. You know very well what this means to me."

In the end, there was little she could to restrain him. He vowed again and again that he would return unscathed. All that was left to her was to pray unceasingly to the Virgin for his safety.

It was called the Abraham Lincoln Battalion. After less than two months' training, the volunteers were given guns loaded with one hundred bullets and sent to fight. In late February, during a useless assault on Nationalist positions that history would call the Battle of Jarama, that North American contingent of Republican forces lost two-thirds of its men, including Daniel Garza.

The tragic outcome took time to reach Daniel's family, who then sent one of his siblings to break the news to Isabel.

She was shattered.

When his body was laid to rest in San Antonio, she wept inconsolably, throwing herself on the coffin in despair. Her family took her home and tried

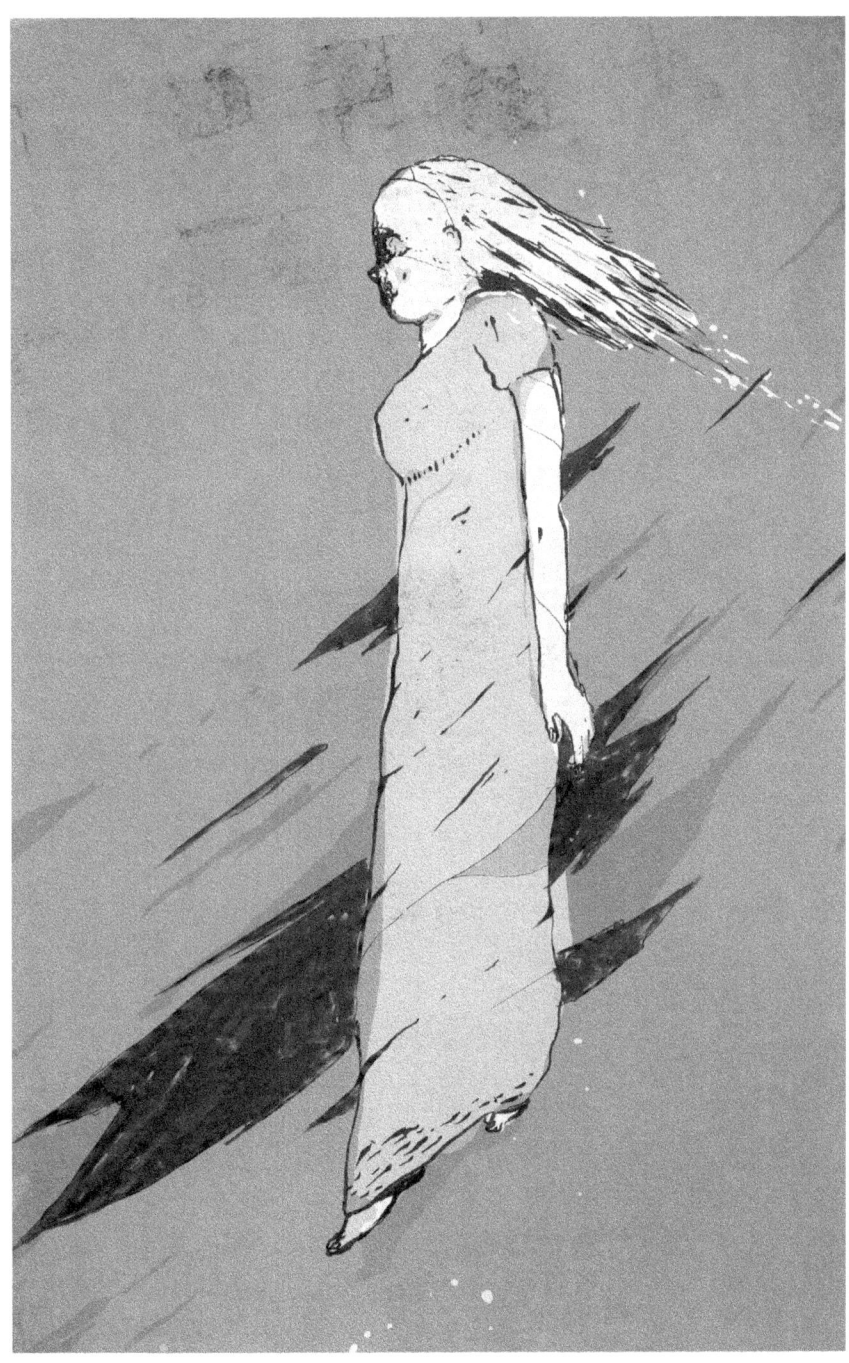

The Lady in White of Roma. *José Meléndez.*

to help her through her grief, called their priest and the mother superior to ease her aching soul, but her faith was unraveling.

"Why?" she demanded of the stars. "Why set him in my path if you were just going to take him away? Why forbid my marriage to you, O Christ, if you planned to refuse me to anyone else?"

In a state of hysterical shock, she finished sewing her wedding dress and began to wear it, wandering the streets at night. Once, she thought she saw Daniel out of the corner of her eye. She pursued the mirage, running barefoot up and down the plaza, wearing the hem of her gown to mangled shreds.

There was little her family could do. Her mind had simply snapped.

"He's alive!" she hissed at them when they tried to rein her in. "We've been lied to! Franco had him prisoner, but he's returned. No one can know. He's waiting for me, in secret. I just have to keep looking."

Isabel wore her soul and body out with the mad quest of her bereavement. Exposed to the elements, she fell deathly ill with pneumonia and died.

But her spirit was not satisfied. It clings to the center of that venerable town, searching for its eternal twin, the mate from which fate so cruelly cut it off.

The people of Roma have seen her, restlessly scouring the historical district, floating from church to convent and all along the plaza.

Her wedding gown flutters eldritch white against the darkness, a symbol of undying love.

BIBLIOGRAPHY

Alonzo, Armando C. *Tejano Legacy: Rancheros and Settlers in South Texas, 1734–1900*. Albuquerque: University of New Mexico Press, 1998.

Anders, Evan. *Boss Rule in South Texas: The Progressive Era*. Austin: University of Texas Press, 2013.

Bennett, Gillian, and Paul Smith. *Contemporary Legend: A Reader (New Perspectives in Folklore)*. New York: Routledge, 1996.

Bowles, David. *Border Lore: Folktales and Legends of South Texas*. Beaumont, TX: Lamar University Press, 2015.

———. *Mexican Bestiary*. Donna, TX: VAO Publishing, 2012.

———. *The Seed: Stories from the River's Edge*. Spring, TX: Absey & Co., 2011.

Brunvand, Jan Harold. *Encyclopedia of Urban Legends, Updated and Expanded Edition*. 2nd rev. ed. Santa Barbara, CA: ABC-CLIO, 2012.

De León, Arnoldo. *War along the Border: The Mexican Revolution and Tejano Communities*. College Station: Texas A&M University Press, 2012.

Elizondo, Lizeth. "A Father's Love: François LaBorde's Letters." Not Even Past. Accessed February 27, 2016. https://notevenpast.org/a-fathers-love-francois-labordes-letters/.

Bibliography

Gerhart Fort, Karen. *Images of America: Mission*. Charleston, SC: Arcadia Publishing, 2009.

Glazer, Mark. *Flour from Another Sack & Other Proverbs, Folk Beliefs, Tales, Riddles, & Recipes*. Revised edition. Edinburg, TX: Pan American University Press, 1994.

González, Jovita. *The Woman Who Lost Her Soul and Other Stories*. Houston, TX: Arte Público Press, 2000.

Handbook of Texas Online. Texas State Historical Association. https://tshaonline.org/handbook.

Hawthorne, John, ed. *The Ghosts of Fort Brown: An Informal Study of Brownsville Folklore and Parapsychology*. Brownsville, TX: Arnulfo L. Oliveira Literary Society, 2003.

Johnson, Benjamin Heber. *Revolution in Texas: How a Forgotten Rebellion and Its Bloody Suppression Turned Mexicans into American*. New Haven, CT: Yale University Press, 2005.

Paredes, Américo. *Folktales of Mexico*. Chicago: University of Chicago Press, 1970.

Salinas, Martín. *Indians of the Rio Grande Delta: Their Role in the History of Southern Texas and Northeastern Mexico*. Austin: University of Texas Press, 1990.

Sauvageau, Juan. *Stories That Must Not Die*. San Antonio, TX: National Educational Systems, 1989.

Silva-Bewley, S. Zulema. *The Legacy of John H. Shary: Promotion and Land Development in Hidalgo County, South Texas, 1912–1930*. Edinburg: University of Texas Pan American Press, 2001.

Young, Elliot. *Catarino Garza's Revolution on the Texas-Mexico Border*. Durham, NC: Duke University Press, 2004.

About the Author

A lifelong resident of deep South Texas, David Bowles is a professor at the University of Texas–Rio Grande Valley. Drawn to the culture, history and folklore of Mexico and the southwestern United States, he focuses on the study of indigenous philosophy, mythology and legend through primary sources. In 2014, the Texas Institute of Letters awarded his book *Flower, Song, Dance: Aztec and Mayan Poetry* the Soeurette Diehl Fraser Award for Best Translation. Bowles is the author of several other titles, most significantly the Pura Belpré Honor Book *The Smoking Mirror* and *Border Lore: Folktales and Legends of South Texas*. Work by Bowles has appeared in venues such as *Translation Review*, *Metamorphoses*, *Asymptote*, *Rattle*, *Axolotl*, *Huizache*, *Concho River Review*, *Border Senses*, *Langdon Review of the Arts in Texas* and *Parabola*.

Visit us at
www.historypress.net

This title is also available as an e-book

www.ingramcontent.com/pod-product-compliance
Lightning Source LLC
Chambersburg PA
CBHW042142160426
43201CB00022B/2381